# From Renaissance to Rodin:
# Celebrating the Tanenbaum Gift

# From Renaissance to Rodin: Celebrating the Tanenbaum Gift

Alison McQueen

This book is published on the occasion of the exhibition
*From Renaissance to Rodin: Celebrating the Tanenbaum Gift,*
presented at the Art Gallery of Ontario, October 1, 2011 – April 1, 2012.

Publisher: Joseph M. Tanenbaum
Author: Alison McQueen
Photography: Courtesy of the Art Gallery of Ontario
Design and Production: Branka Vidovic, NeoGraphics

For information on ordering contact:
ABC Art Books Canada
www.abcartbookscanada.com

McQueen, Alison, 1969-
    From Renaissance to Rodin : celebrating the Tanenbaum gift / Alison
McQueen.

Includes bibliographical references.
Catalogue of an exhibition held at the Art Gallery of Ontario, Toronto,
    Ont., from Oct. 1, 2011 – April 1, 2012.

ISBN 978-1-927371-32-9

    1. Art, European--Exhibitions.  2. Tanenbaum, Joseph M.--Art
collections--Exhibitions.  3. Tanenbaum, Toby--Art collections--
Exhibitions.  4. Art Gallery of Ontario.  I. Tannenbaum, Joseph M
II. Art Gallery of Ontario  III. Title.

N6750.M36 2012          709.4'074713541          C2011-908732-4

# Table of Contents

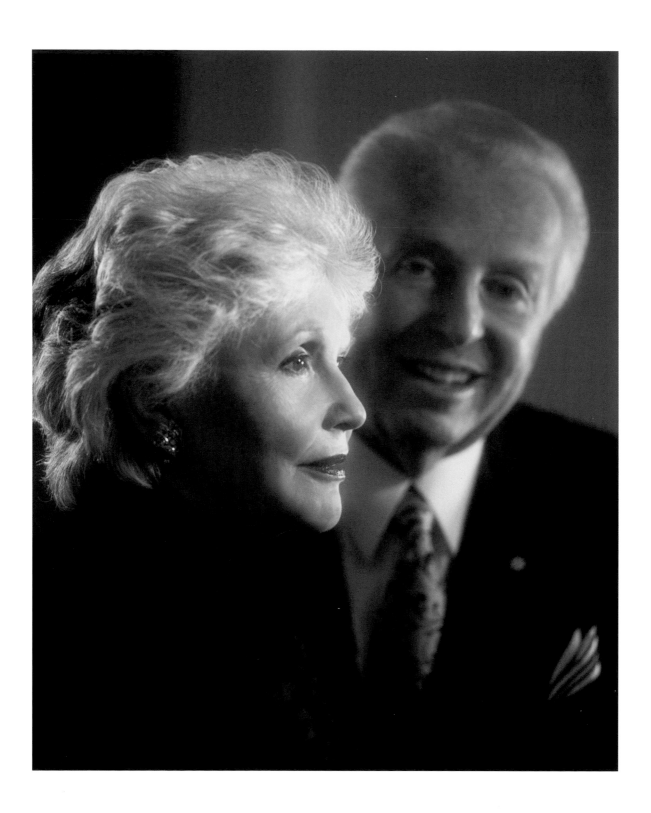

# Collector's Preface

Honoured Guests, Ladies and Gentlemen:

This evening of Tuesday, October 4, 2011 is the most exceptional event of our lives. Both Toby and I have been involved in the art world since Friday, August 6th of 1964 when my late father berated me for spending $100 for, and I quote, "Some schmo-blow to paint in oil."

That was when I called Toby at home and told her "From today on we will be collecting art in order to upset my old man."

It was, no doubt, the best decision of my life.

To be able to see one of the most prestigious collections of Old Master art, which we gifted to the AGO over a period of 40 years, being exhibited for the first time in two of the largest galleries at the AGO, is truly a momentous occasion for us.

Knowing that a gift like this may never be duplicated again — justifies our devotion of giving back to our beloved country of Canada a token of our appreciation for the freedom this country has given to all who have arrived here as immigrants. Just like my beloved grandparents who escaped from Poland in 1911 with only eight dollars in my grandfather's pocket, and he started as a pedlar with a push cart. He created the beginning of one of the largest steel fabrication and distribution companies in Canada by the third generation, which I was so fortunate to continue operating in his footsteps.

So Ladies and Gentlemen we thank Matthew Teitelbaum, Director and CEO of the AGO, and his most competent colleagues who have mounted this historic gift to the AGO, and especially to Dr. Lloyd DeWitt, Curator of European Art, and his close associate Sasha Suda.

Thank you everyone for coming here this evening to honour us.

*Remarks given by Joey Tanenbaum at the reception*
*celebrating the inauguration of the exhibition.*

# Curator's Preface

This volume celebrates the installation at the Art Gallery of Ontario of the gifts of Joey and Toby Tanenbaum and their family members over many decades. As a group, it ranks among the greatest gifts of Old Master paintings to a public museum in Canada's history, a gift crowned by the bust of Gregory XV, a crucial papal commission by Bernini. Drama and narrative are a common thread in the works of the group, which span from the Renaissance to the early twentieth century, and set these works apart from those that dominated Canada's public collections when first assembled, when simplicity and sobriety were prized. The stupendous Gaspar de Crayer *St. Benedict and Totila* painted for the monastery in Afflighem, and the two powerful figures from Auguste Rodin's heartrending *Burghers of Calais* set the tone of boldness and ambition, while other works like the Játiva Master's *Crucifixion*, an important early Spanish work, and the richly painted and arcane *Dream of Raphael* by Jan Breughel and Hans Rottenhammer show the collectors' sensitivity and confidence. Both Coypel's *Crucifixion* and Lunetti's *Adoration of the Magi* boast illustrious provenances, as do many others. These works enrich the AGO's permanent collection by filling in gaps (especially in Italian painting) and adding to strengths such as Flemish art and contributing works of singular importance, such as Bernini's key *Bust of Gregory XV*. The installation at the Art Gallery of Ontario owes much to the efforts of many other talented and dedicated colleagues at the AGO. The installation aims to communicate how Joey and Toby, who have made great art such an integral part of their own lives, have made it an integral part of the life of their community and country.

*Lloyd DeWitt*
*Curator of European Art*
*Art Gallery of Ontario*

## Author's Acknowledgements

I am grateful to the curators who contributed to the AGO's research files on these objects over many years and I note in particular David McTavish, Nancy Minty, Christina Corsiglia, Alan Chong, Martha Kelleher, Brenda Rix, Katharine Lochnan, and especially Janet Brooke whose extensive research particularly at the time of Joey and Toby Tanenbaums' donations in 1995 made a significant contribution to the gallery. I thank Lloyd DeWitt, curator of European Art, for granting me access to these files and for his support of this project. I also thank Wendy Hebditch, administrative assistant, European Art, for her help with numerous details. Sean Weaver, coordinator, Image Resources, worked tenaciously to make possible the excellent photographs that illustrate this catalogue and I thank him for his efforts. I am most appreciative of Erin Wall's thorough and reliable assistance. Erick Spencer at Jay-M Holdings offered his help with acquisition details for various works. Branka Vidovic has contributed much with her work on the design and production of the catalogue. And I am very thankful to Rod McQueen for his advice and comments.

Above all, I thank Joey and Toby Tanenbaum for offering me the opportunity to work on the fascinating pieces they and their family have donated to the Art Gallery of Ontario. It has been a privilege and an honour to write and create this catalogue.

Alison McQueen is Associate Professor of Art History at McMaster University. Her book *Empress Eugénie and the Arts: Politics and Visual Culture in the Nineteenth Century* (2011) was awarded a prize from the Fondation Napoléon in Paris. Professor McQueen is also author of *The Rise of the Cult of Rembrandt: Reinventing an Old Master in Nineteenth-Century France* (2003). She is co-author of *Collecting in the Gilded Age: Art Patronage in Pittsburgh, 1890–1910* (1997) and *Félix Buhot: Peintre graveur entre romantisme et impressionisme, 1847–1898* (1998). Professor McQueen has undertaken research on the Tanenbaum's collection for over a decade and she contributed an essay to the exhibition catalogue *Heaven and Earth Unveiled: European Treasures from the Tanenbaum Collection* (2005).

# From the Renaissance to Rodin: The Tanenbaum donations to the Art Gallery of Ontario

Alison McQueen

Joey and Toby Tanenbaum rank among Canada's most prominent art collectors. Their donations have transformed many of Canada's leading cultural institutions including the National Gallery of Canada, the Royal Ontario Museum, the Art Gallery of Greater Victoria, the Art Gallery of Hamilton, and the Art Gallery of Ontario.[1] In 2000 they were named Canada's *Outstanding Philanthropists of the Year* and in 2004 the Canadian Museums Association recognized the eminent nature of their patronage with the *Award for Outstanding Achievement in Philanthropy*. In 2011 Joey and Toby were named among the "Top 200 collectors" in the world by *ARTnews* magazine.[2] It is important to note that both Joey and Toby were cited on this list. While Toby's role has been less public and therefore less well known to many in Canada, she has been an equal participant in all decisions regarding the Tanenbaum's art purchases and donations. Joey's lifetime of outstanding achievement and remarkable service to the nation was recognized by his appointment to the Order of Canada in 1996. The motto of this Order, "They desire a better country" (Desiderantes Meliorem Patrium), underlines the extent to which they have both given back to Canada.

Lloyd DeWitt, curator of European Art at the AGO, curated the exhibition *From Renaissance to Rodin: Celebrating the Tanenbaum Gift*. It is on view from 1 October 2011–1 April 2012 and marks the first time when the many works donated by the Tanenbaum family have been exhibited together at the AGO. The exhibition includes thirty-seven works by thirty artists from eight countries. These works were produced over more than four centuries, from the late fifteenth century to the early twentieth century. This catalogue offers a lasting record of the exhibition and underscores the significance of the donations.

At a personal level, Joey and Toby Tanenbaum's donations to the AGO provide genuine insight into their passionate collecting of art that evokes a strong human quality. This is conveyed particularly through the number of works that manifest emotional and dramatic representations of the human body, psyche, and spirit. The breadth and quality of the collection also testifies to their acumen. Their skills as connoisseurs were developed in part through their relationships with numerous dealers including the Schickman Gallery, Jack Kilgore, and Otto Nauman in New York, Peter Silverman in Paris, as well as the Bruton Gallery, Charles Jerdein, and Norman Leitman in London. While these knowledgeable dealers were the source of many important purchases, Joey and Toby also bought art at auction from Sotheby's and Christie's in Monaco, London, Rome, and New York.

Nothing in the upbringing of either Joey or Toby nurtured their interest in art. "I had no history whatsoever in art at all because we were a family brought up in the steel business," Joey recalls. "There was no art, period. [For] my late beloved grandfather, being an orthodox Jewish man, it was sinful to have the creation of people [represented in images], they always felt that it was against the wishes of G[-]d." Toby also grew up in an orthodox Jewish home but as a young girl she was drawn to strongly coloured, finely made forms, in particular a cobalt blue basket with a silver filigree handle that sat on the piano in her family home.[3]

As a couple, their taste for collecting was ignited by the negative response that their first acquisition elicited from Joey's family. In the early 1960s, after almost ten years of marriage, Joey and Toby moved into an English Tudor style home with wood panelling. They thought old English paintings would be the appropriate decor for this new setting, so they went to Britnell's on Yonge Street, a bookstore that at the time also sold art. They made their first purchase on 15 July 1964 of an oil painting Joey can only vaguely recall today: "It was nothing. It was just a little girl, a little boy, playing with some bunny rabbits. It was absolutely nothing. What did we know?" They paid one hundred dollars and Joey wrote "Re: painting" at the bottom of the cheque. In those days, Joey's bank account was personally guaranteed by his father, who reviewed his cancelled cheques on the first Friday of every month. On the first Friday of August, Joey went to work at York Steel and was summoned into his father's office. There, his father Max closed the door and asked, "Joey, tell me something, are you my son?" Joey replied, "I think so Dad. I don't know. I mean, you should know more than I do, but I think so." To this Max said, "Tell me,

how could my son spend a hundred dollars for some *schmo-blow* to paint in oil?" Joey replied, "Dad, the painting talks to me." Max answered, "Talks to you, *shmalks* to you. Better you should invest in the stock market!" Joey and Toby decided there and then to prove his father wrong and committed themselves to developing an art collection.[4]

As a first step, the Tanenbaums began attending the Tom Phyfe auctions in Leaside, in east Toronto. At the time they thought that anything colourful was art. When friends saw the dozen works they had acquired for their home, one of them took the couple aside, told them they lacked direction, and suggested they read *Apollo* and *Connoisseur* magazines. "We saw that we were really floundering, that we had to get proper advice," said Joey. Wide reading led them to Victorian art through dealers in London, England, but it was not until 1968, when a friend introduced them to David Brooke, then chief curator at the Art Gallery of Ontario, that they began to form a thoughtful collecting practice. Brooke was organizing an exhibition on Tissot and advised the Tanenbaums on their first major purchase: Tissot's *The Staircase* (1869). Today the Tanenbaums consider this work their "first acquisition" and Tissot became one of their favoured artists.[5]

The Tanenbaums began biweekly pilgrimages to New York to scour commercial art galleries including Shickman, Wildenstein, Schweitzer, and Shepherd. Building on their Tissot purchase, they started buying French art from the second half of the nineteenth century. Since works by the Impressionists were already priced beyond their reach, they focused on the teachers and contemporaries of the well-known artists. From there, they expanded their interests to include Old Master paintings, particularly of the Renaissance and Baroque periods. Joey has always

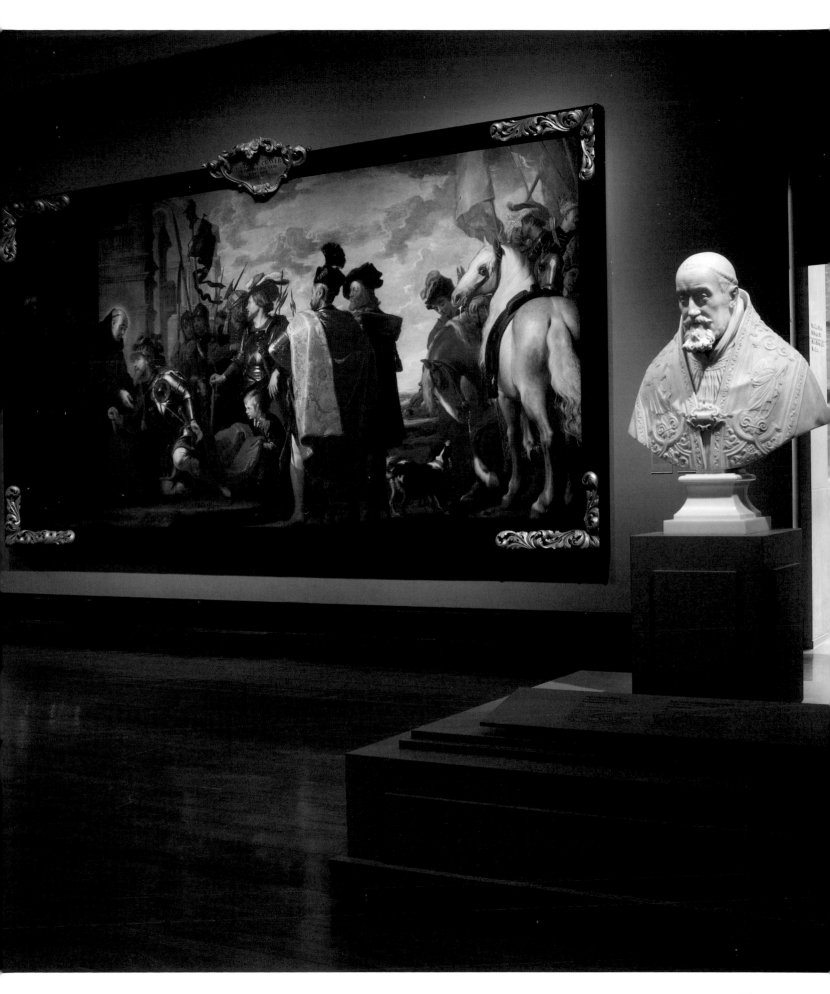

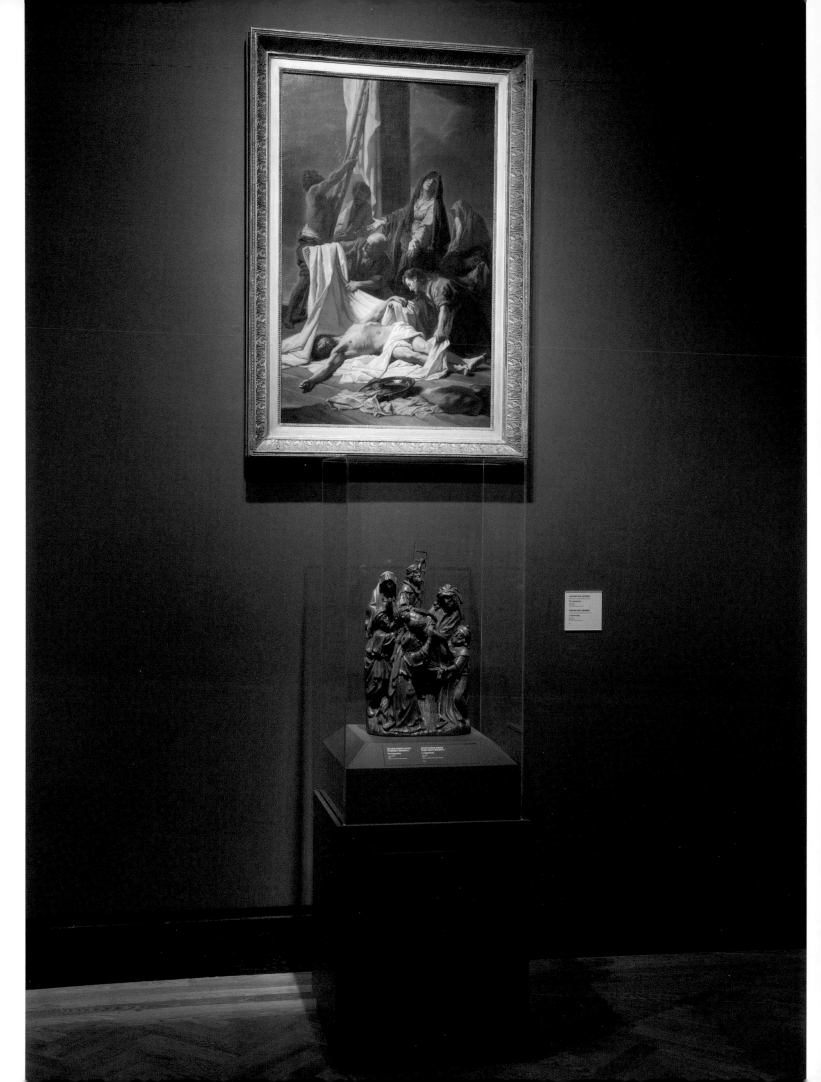

approached art collecting as he does his business transactions. "Don't deal with the fringe element in the art world," he advises. "Don't go bargain hunting; and consult experts."[6]

The earliest of the Tanenbaum family's donations of art works to Canadian institutions enriched their native Toronto and the collection of the Art Gallery Ontario. In 1971 Joey and Toby donated British artist George Frederick Watts' *The Sower of the Systems* (1902, cat. 36) to the Ontario Heritage Foundation. In those early years of their patronage, this was the route one followed to donate a work to the AGO and the painting was considered on long-term loan to the gallery until 1988, by which point practices had changed. Their patronage also altered the view toward art of Joey's parents. In 1971, Max and Anne Tanenbaum donated their first work to the AGO, again via the Ontario Heritage Foundation. This was Russian artist Prince Paolo Troubetzkoy's *Portrait of Comte Robert de Montesquiou-Fézensac* (c. 1910, cat. 37), a substantial painted plaster that Max and Anne acquired from Galerie Vaughan in Brussels and had delivered directly to the AGO.

Their generous gifts continued. In 1985 Joey and Toby made their first direct donation to the AGO with *The Adoration of the Shepherds* (1520–1540, cat. 6), a painting attributed to Italian Renaissance artist Tommaso di Stefano (called Lunetti). This was followed in 1986 with another Renaissance work, *Allegory of Life* (1595, cat. 10), executed collaboratively by Jan Breughel the Elder and Hans Rottenhammer. Donated in loving memory of Joey's father who died in 1983, this luminous scene painted on copper evokes the very life force for which they remembered Max Tanenbaum. In 1986, Joey's mother Anne also gave Jan Victors' *The Levite and his Concubine at Gibeah* (1644, cat. 17) to the

AGO in Max's memory. She and Max had acquired the painting over a decade earlier. In 1986, this year of commemorative family donations, Joey and Toby also gave Barent Fabritius' *Self-Portrait* (c. 1650, cat. 18) in memory of Mario Amaya. Amaya was chief curator at the AGO from 1969–1972 and was a great supporter of Joey and Toby's growing interest in art collecting.

Donations continued in 1988 when the Tanenbaums gave to the AGO *The Expulsion of the Money-Changers* (c. 1480–1500, cat. 1), a work attributed to the Master of the Kress Epiphany. Another significant gift followed in 1990 with Joseph Wright of Derby's *The Storm: Antigonus Pursued by the Bear* (1790–92, cat. 28). In 1989, Joey's mother Anne also gave Adriaen Pietersz. Van de Venne's *Dancing Peasants* (c. 1635, cat. 15) and in 1991 the family donated Giordano's *The Toilet of Bathsheba* (c. 1663, cat. 21), again in memory of Joey's father Max. Max and Anne had acquired this painting in 1972 from the Heim Gallery in London following Joey's recommendation. Joey often advised his parents on their purchases and they acquired works from some of the same dealers as Joey and Toby, as well as at auction.

Joey and Toby have also made significant donations to the AGO in the form of sculpture, including two bronzes by Auguste Rodin, *Andrieux d'Andres* and *Eustache de Saint-Pierre* (cat. 34 & 35), in 1992. These are individual castings of two of the six hostages expressively rendered in Rodin's renowned *Burghers of Calais* (1885–95). The Tanenbaums acquired the sculptures in 1988 and 1989. Before their donation to the AGO, the two figures stood in the offices of Jay-M Holdings Limited, of which Joey Tanenbaum is the founder and chair. *Eustache de Saint-Pierre* occupied a place in the boardroom and *Andrieux d'Andres*, holding his head in his hands,

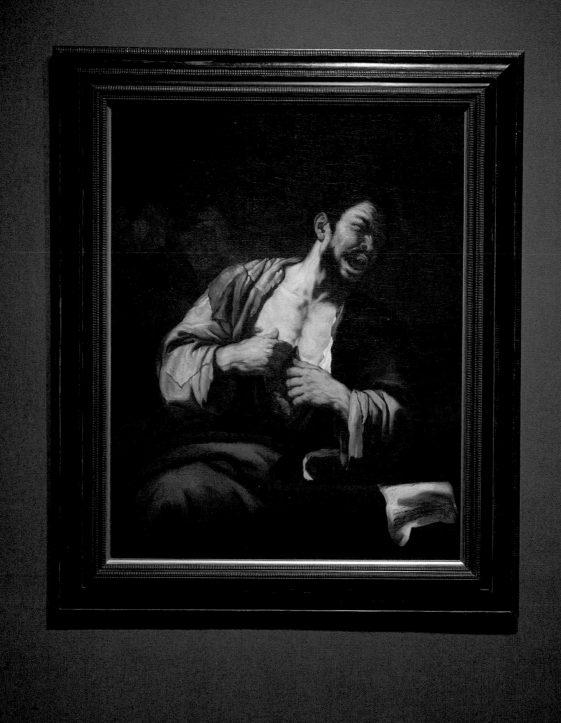

was positioned immediately next to Joey's desk where he offered evocative companionship in the context of the challenges and sacrifices of professional life. Returning to gifts of paintings in 1994, the Tanenbaums offered Horace Vernet's *Battle of Pirates, Sunrise* (1818, cat. 31), a work that from its origin had held pride of place in various prestigious collections. Vernet had sold it to Louis-Philippe, the duc d'Orléans, who kept the painting in his possession throughout his reign as king of France (1830–48), until his death in 1850. In addition to the gifts of art works, from 1989 to 1993 the Tanenbaums also committed $6,650,000 towards five different projects during the gallery's Stage III expansion: two galleries (named for Max & Anne Tanenbaum, and Carol & Ernie Sheriff), the Sculpture Atrium, a Gallery School, and a Centre for European Art.

The Tanenbaums' largest donation to the AGO in terms of the number of objects took place in 1995, with their gift of sixteen paintings from five regions of Western European art spanning more than two centuries. The majority were Flemish, many depicting religious subjects — among them Artus Wolffort's *Saint Bartholomew* (c. 1616, cat. 12), Pieter Claeissens the elder's (attributed) *Moses Breaking Pharaoh's Crown* (c. 1530–1572, cat. 7), and Tobias Verhaecht's *Mountain Landscape with Figures* (c. 1590–1630, cat. 9). They also donated three large-scale compositions by Gaspar de Crayer that are linked by monastic themes: two of them focused on the Cistercian order, *A Cistercian Bishop with the Young Christ* and *The Admission of Saint Bernard to the Cistercian Order* (both c. 1660, cat. 19 & 20), and one on the Benedictine order, *Saint Benedict Receiving Totila, King of the Ostrogoths* (1633, cat. 14), originally painted for the refectory of the Benedictine Abbey of Saints Peter and Paul in Affligem. Three Spanish paintings also figured in the donation: the Játiva Master's *The Crucifixion* (late 1400s, cat. 3), Esteban Márquez de Velasco's *The Dormition of the Virgin* (1690s, cat. 26), originally commissioned for the Convent of La Trinidad Calzada in Seville, and, most notably, Jusepe de Ribera's poignantly realist *Saint Jerome* (1614–15, cat. 11). Three of the Dutch and French works were linked thematically through their emphasis on the transitory nature of life: a skull figures prominently in Hendrick Andriessen's *Still Life, (Vanitas)* (c. 1637, cat. 16), as does Christ's abject body in both Jean Jouvenet's *The Lamentation* (c. 1704, cat. 27) and Antoine Coypel's *The Death of Christ on the Cross* (1692, cat. 25). Coypel's painting is another work originating from a celebrated collection; it was executed for the duc de Richelieu over a decade before Coypel was named First Painter to the king of France (1715). The Italian paintings included works by Neapolitan artist Luca Giordano: *The Crucifixion of Saint Andrew* (c. 1660, cat. 22), and *Astronomy* (c. 1653–54, or 1680–1692?, cat. 23). Another work, *The Battle between the Israelites and the Amalekites* (1689–90, cat. 24), was attributed to Giordano in 1995 and is now assigned to Giuseppe Simonelli. The Tanenbaums' particular affinity for the theatricality of much Baroque art can also be experienced in the current exhibition through Giordano's dramatic painting *The Suicide of Cato* on loan from the Art Gallery of Hamilton (see facing page).

It was also in 1995 that Anne Tanenbaum gave four paintings to the Government of Ontario, with the express wish that they be placed on long-term loan to the AGO. These included two impressive portraits, one by French artist Eugène Devéria, *Portrait of the Comte Henri de Cambis d'Orsay* (1839, cat. 33), and the other by British artist Thomas Lawrence, *Portrait of Hart Hart-Davis* (after 1820,

cat. 32). Anne also donated two fascinating sixteenth-century Flemish panels attributed to Pseudo-Bles, *The Messengers with the Water Before David* and *The Queen of Sheba visiting King Solomon* (c. 1515–1520, cat. 4 & 5).

Joey and Toby Tanenbaum's most notable donation to the AGO occurred in 1997 and this gift again underscores their ongoing fascination with the power of Baroque art. Bought by the Tanenbaums in 1980, by 1998 leading scholars had identified this work as a bust of *Pope Gregory XV* by Gian Lorenzo Bernini (cat. 13) and gave it a prominent position in an exhibition at the Palazzo Venezia in Rome. This successful purchase was initiated by the strong aesthetic sensibility of Toby, who declared her interest in buying the work after seeing it reproduced in *Apollo.* "I always loved it because of its colour," said Toby. "It had an alabaster look to it. I'm not a lover of white marble, but this was different. There was just such a humane look about it." They also credit their art consultant in London, Norman Leitman, whom Joey later described as their "eyes and ears in Europe."[7] The bust enjoys a place of honour in the European galleries and is among the AGO's single most important works of art. From 1992 to 1997 the Tanenbaums donated twenty-three works of art to the AGO, with a total value of $65 million.

In 1999 their generous gifts to the AGO continued with a complete suite of eighty prints and rare first edition of *Los Caprichos* (1796–98, cat. 29) by Francisco Goya. Also in 1999, the Tanenbaums' son Robert donated another first edition of Goya's *Los Proverbios* (1816–1824, cat. 30), a set of eighteen prints he received from his parents in 1997. The final work in the exhibition, *Deposition*, an oak sculpture by an unknown Flemish artist dated c. 1490, is on long-term loan to the gallery from Joey and Toby. Speaking to the importance of the Tanenbaum's numerous donations to the AGO, the museum's director Matthew Teitelbaum said, "The Tanenbaum family, that is to say Joey and Toby, his mother, and before that his father, contributed enormously to the success of the Art Gallery of Ontario and one need only walk through the European gallery to get a sense of the number of works which are now a part of the public identity of the institution that came to us through their generosity."[8]

Despite the public accolades Joey and Toby's talents as art collectors were never fully recognized by Joey's father Max. Joey recalls a dialogue from 1973 between a developer and his father: "Max," said the developer, "I'm going to Joey and Toby's tomorrow night for dinner and I'm really looking forward to it" — to which Max replied, "When you go there you're gonna see the most expensive goddamn wallpaper in the whole world!" Even after the Toronto showing of *The Other Nineteenth Century*, an exhibit organized by the National Gallery of Canada, compliments from Joey's father's remained indirect.[9] When the head of the Israel Discount Bank commented, "Max, your son's collection is unbelievable!" Max responded, "Well, I'm going to tell you something. My son wasn't as stupid as I thought." Perhaps the greatest hurdle for Joey's father was his son's attraction to Christian subjects. A painting by Jean-Jacques Henner, *Christ on the Cross* (now in the collection of the Art Gallery of Hamilton), hung over Joey's desk in the Hamilton offices of the Bridge and Tank Company of Canada and aroused his father's ire. Max asked, "How could you have a picture of Christ on the cross hanging in your office? You're a good Jewish boy, how could you do that?" Joey replied. "Dad, don't you know, Christ

was originally Jewish before he became Christian" — a response that appeased his father.

Collectors such as the Tanenbaums are key to enabling Canadian institutions, such as the Art Gallery of Ontario, to compete internationally. While some museums can make substantial purchases, patrons like the Tanenbaums make it possible to acquire a greater number of high-quality works in a short period of time. Such patronage enables growth in new directions, often fostering far-reaching relationships, and helps to build international stature through loans to foreign exhibitions. Joey has frequently declared the public spirit of the aspirations he and Toby have for their donations to Canadian art galleries and museums. He has sincerely and passionately quoted from the Torah, citing Hebrew prayers on how one should respond to good fortune, and he has spoken philosophically about the importance of making a public impact for the better. This exhibition, *From Renaissance to Rodin: Celebrating the Tanenbaum Gift*, includes numerous high-quality works, some of which can only be seen infrequently due to their impressive scale. This exhibition and catalogue offer a unique opportunity to view the gifts by the Tanenbaum family as well as provide an enriching study of important artists and traditions in the history of Western European art.

---

1 For an analysis of Joey and Toby Tanenbaum's donations to other Canadian institutions see Alison McQueen, "A Couple's Passion: The Joey and Toby Tanenbaum Art Collection," in *Heaven and Earth Unveiled: European Treasures from the Tanenbaum Collection*. Hamilton: Art Gallery of Hamilton, 2005, 191–200.

2 Esterow, Milton. "The ARTnews 200 Top Collectors," *ARTnews* (Summer 2011): 85–88, 90, 92–94, 96–98.

3 The author interviewed Toby Tanenbaum 17 January 2001, 14 March 2001, and 21 June 2011.

4 Unless otherwise noted, all quotations of Joey Tanenbaum are taken from the author's interviews 4 December 2000, 17 January 2001, 17 May 2011, and 13 October 2011.

5 Joey recalls purchasing the painting for $1,750 in 1968 and selling it to American-based collector Fred Koch for over $1 million in 1983.

6 Cited by Patricia Anderson in "The Education of an Art Collector," *The Financial Post* (14 July 1979).

7 Geraldine Norman, "Collecting on a Monumental Scale," *The Independent on Sunday* (22 May 1994), 70.

8 The quotation from Matthew Teitelbaum is from the author's interview 31 October 2001. The Tanenbaums also donated a seventeenth-century gilded Italian frame to the AGO in 2000 (Inv. 2000/82), as well as a drawing by Belgian artist Firmin Blaes, *Women Making Lace* (1906, AGOID.19501), neither of which were included in the current exhibition.

9 Douglas Druick and Louise d'Argencourt. *The Other Nineteenth Century: Paintings and Sculpture in the collection of Mr. and Mrs. Joseph M. Tanenbaum*. Ottawa: National Gallery of Canada, 1978.

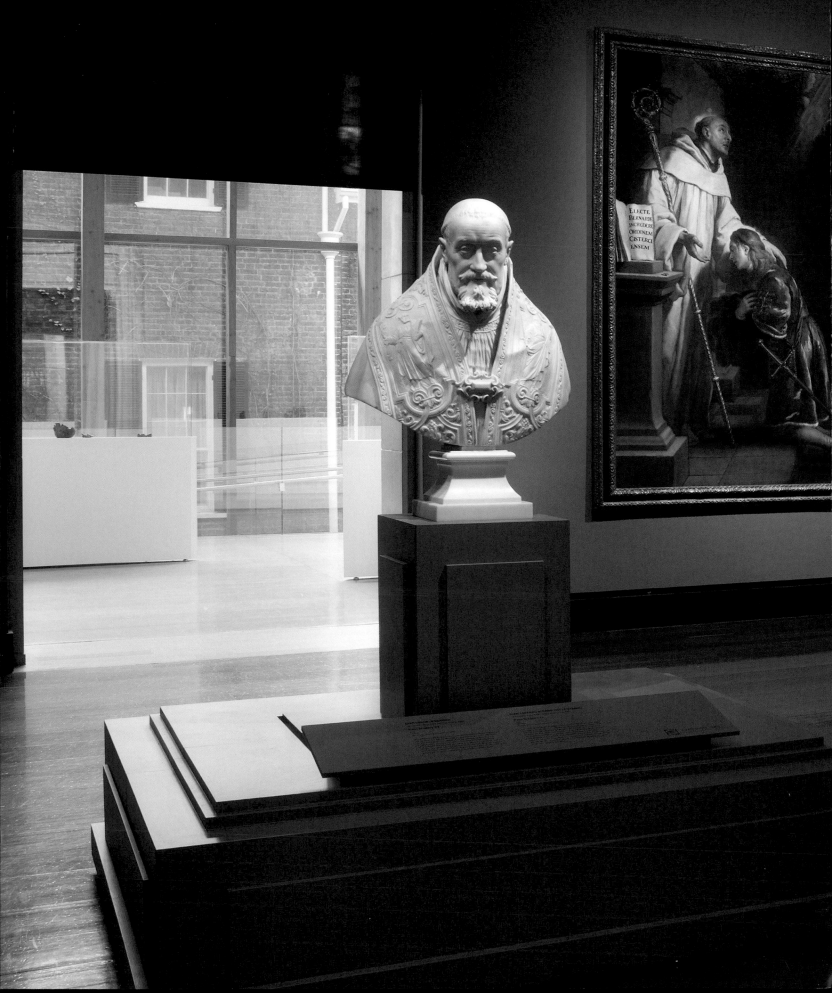

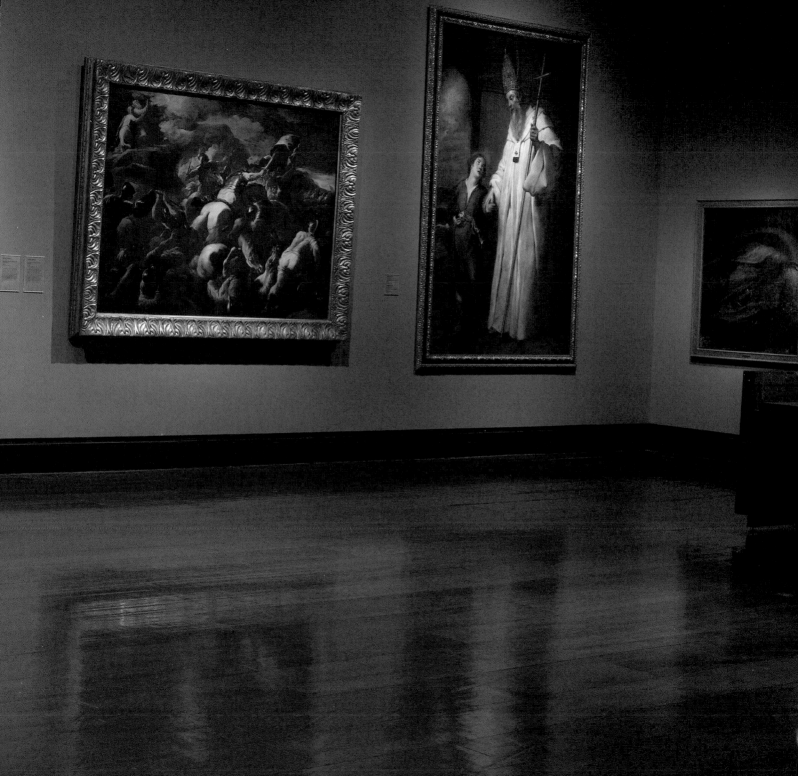

cat. 1

# Master of the Kress Epiphany, attributed to (Dutch, active 1475–1499)

## *Expulsion of the Money-Changers*

c. 1480–1500, oil on panel, 167 x 98 cm
Gift of Joey and Toby Tanenbaum, 1988 (Inv. 88/340)

Christ appears on the left brandishing a knotted whip and approaches the table of the money-changers in the Temple in Jerusalem. Recounted in each of the four Gospels, the subject is typically depicted as an active scene of physical confusion in which the traders gather their money and flee, driving the animals in front of them. Here the artist focuses instead on the moment when the money-changers first catch sight of the one who condemns them. Those closest to Christ gesture their astonishment and lean away while some on the far side of the table seem barely affected. Christ has picked up a tablet of gold and silver coins and is about to throw it as coins begin to fall to the floor. A few curious onlookers lean in the doorway while others in the distant space of the building are oblivious. The sacred space is a Gothic interior that would have looked quite familiar to a viewer when the painting was executed. With the elaborate tracery of the clerestory windows, the ribs of the cross-barrel vaulting, the pointed ogival arches, and the carved protrusions of the roof bosses, the Temple is presented as a contemporary fifteenth-century religious space.

This work is attributed to the Master of the Kress Epiphany, an artist whose name is derived from a large painting now identified as the *Adoration of the Magi* in the National Gallery of Art in Washington, D.C. (1951.5.41). Active in the late fifteenth century, The Master of the Kress Epiphany was likely born and trained in the Netherlands and moved south through Germany and France to Spain, where this work was probably painted. The subject of expulsion has specific contemporary relevance during the events of the Spanish Inquisition when thousands of Jews refused to convert to Catholicism and were expelled from Spain in 1492.

The Master of the Kress Epiphany demonstrates a close affiliation with Flemish and Netherlandish Renaissance art, particularly through the detailed faces and treatment of fabrics, for example the folds of the red drapery in the foreground. The subject is rare in fifteenth-century art and it was almost always part of a Passion cycle. It is, therefore, likely that this painting was originally part of a larger, multi-paneled altarpiece. Large panel paintings of this period are also rare, which adds to the value of this work particularly in a North American collection. The Master of the Kress Epiphany used oil paint to achieve remarkably naturalistic effects and added whimsical elements such as gargoyles and drolleries that add considerable interest to this unusual scene. In a fascinating record of the artist's changes to the composition, we can see the pointed shadow of an ogival arch above the door leading to the courtyard. This *pentimento* is underpainting that has been revealed through time; it would not have been evident when the work was completed.

## Provenance

Paris, Palais Galliera, 26 June 1962, n. 54 (as German, c. 1500)
Paris, Jean Néger, 1965
London, Sotheby's, 28 March 1979, n. 68 (as Northern French, c. 1470)
New York, Schickman Gallery
Toronto, Joey and Toby Tanenbaum, 1987–1988

## Exhibition History

Jerusalem, Israel Museum, 1985–1987

## Bibliography

Eisler, Colin. *Paintings from the Samuel H. Kress Collection.* Oxford: Phaidon Press, 1977.
Strange, Alfred. "Bemerkungen zur gotischen Malerei in Nordfrankreich," *Alte und Moderne Kunst* (January–February 1965): 2–11.

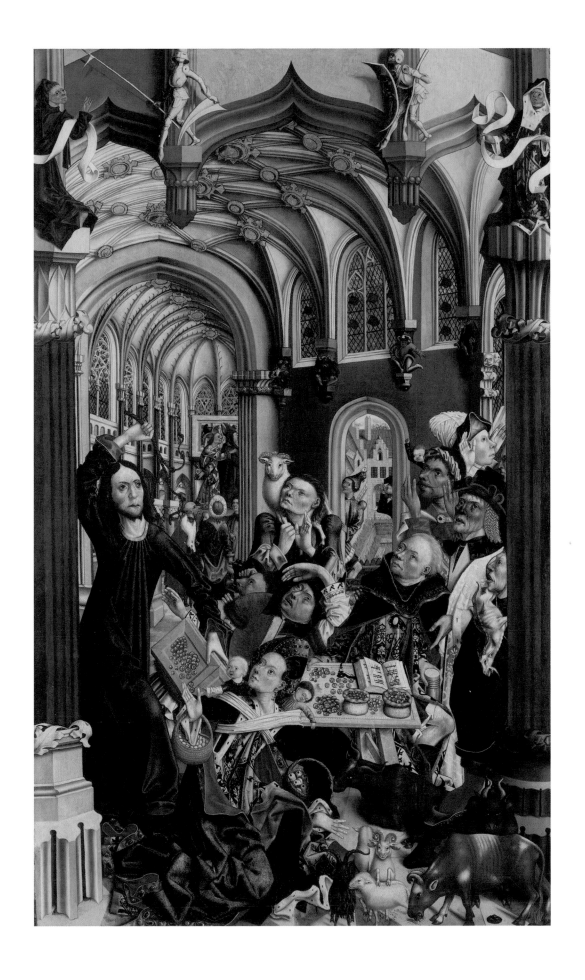

25

cat. 2

# Unknown Artist (Flemish [?], 15th century)
## *Deposition*

c. 1490, oak, 64 x 37 cm
Collection of Joey and Toby Tanenbaum, on long-term loan

The Descent from the Cross, or Deposition, follows immediately after the Crucifixion and is referred to in all of the Gospels. Joseph of Arimathea, a wealthy and well regarded member of Jerusalem's Jewish legislative council, the Sanhedrin, was secretly a follower of Christ and asked Pilate for permission to take Christ's body down from the cross. Joseph is assisted by several men, one of whom is Nicodemus, another member of the Sanhedrin who had visited Christ at night in order to listen to his teaching. This sculpture highlights the moment when Christ's body is placed on the linen sheet brought by Joseph, who is traditionally the figure taking the weight of the upper body — in this sculpture the man kneeling at the base of the ladder. Nicodemus is usually the one to take the weight of the lower body and appears here about to receive Christ's feet. It was Nicodemus who brought the aloes and myrrh that were used to preserve Christ's body before it was swaddled in strips of cloth. Joseph and Nicodemus are usually differentiated from the other figures by their rich dress and hats, which in this work also distinguish the two figures receiving Christ's body. The Virgin Mary holds her hands in prayer and the apostle John the Evangelist typically stands somewhat apart; he is likely the figure standing behind the ladder to the right. The earliest depictions of the Deposition in Western European art date to the 10th century and include four figures but by the 14th and 15th centuries the composition had grown more complex and the number of attendants increased.

Although some of the figures in this Deposition appear to be carved entirely in the round, this is in fact a high-relief sculpture that was originally part of a much larger composition. It likely filled a wing of an elaborately carved altarpiece dedicated to the Passion of Christ, the architectural structure of which is called the *caisse* (French: box). The term retable is often used interchangeably with altarpiece but perhaps more accurately denotes the carved and architectonic form of the original work that was placed above and behind an altar. In such retables, the Crucifixion filled the central scene while Christ on the road to Calvary was depicted on the left and aspects of the Deposition and Entombment were on the right. In that way the narrative aspects were clear to viewers and supported the didactic and spiritual significance of the work in a church setting. Carved retables were an important tradition in the late

Medieval and early Renaissance periods and many of the original sculptures were polychrome, indeed in some instances there were both carved and painted wings. The majority of Southern Netherlandish carved retables were polychromed and covered with layers of gesso, paint, and gilding. The richly decorated altarpieces were seen to embody spiritual values, as material grandeur reflected divine splendor and majesty in the realm of heaven. This particular example is in exceptional condition and may have been produced in the Duchy of Brabant (1183–1648), the artistic centers of which included Brussels, Antwerp, and Leuven.

**Provenance**

South America, Private Collection
New York, Sotheby's, 4 June 2009, n. 71
Toronto, Joey and Toby Tanenbaum, since 2009

**Bibliography**

Borchgrave d'Altena, Joseph de. *Les retables Brabançons, 1450–1550*. Brussels, Editions du Cercle d'Art, 1942.

Jacobs, Lynn F. *Early Netherlandish Carved Altarpieces, 1380–1550: Medieval Tastes and Mass Marketing*. New York: Cambridge University Press, 1998.

Steyaert, John W. *Late Gothic Sculpture: The Burgundian Netherlands*. Ghent: Ludion Press, 1994.

Velde, Carl van de et al eds. *Constructing Wooden Images: Proceedings of the symposium on the organization of Labour and working practices of Late Gothic carved altarpieces in the Low Countries, Brussels 25–26 October 2001*. Brussels: Brussels University Press, 2005.

Williamson, Paul. *Netherlandish Sculpture 1450–1550*. London: Victoria and Albert Museum, 2002.

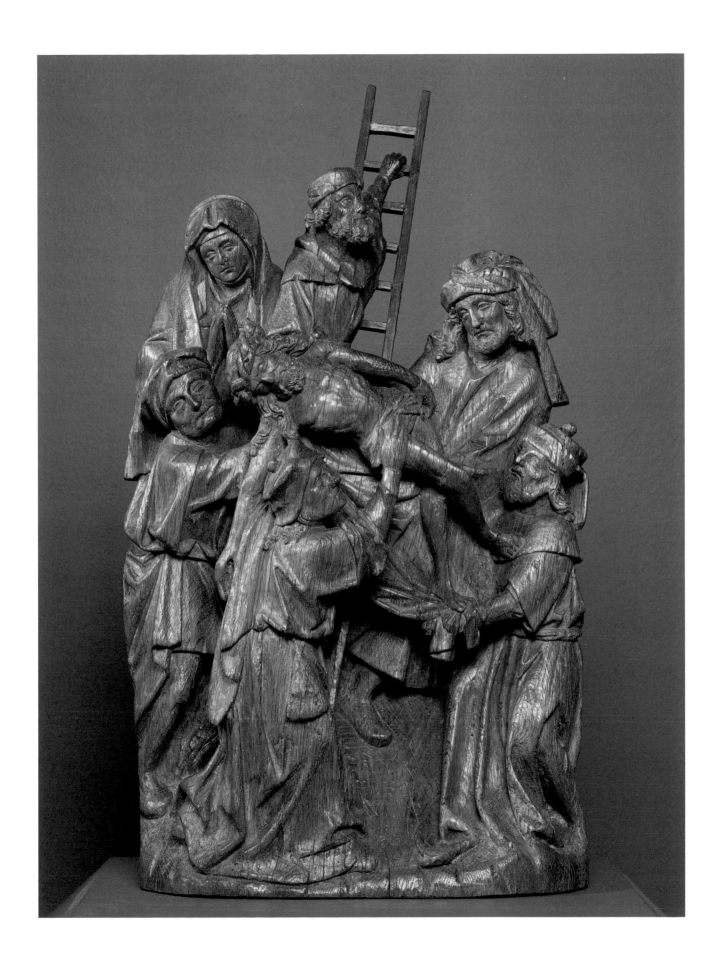

cat. 3
# The Játiva Master (Spanish, active late 15th century)
## *The Crucifixion*
late 1400s, oil on panel lined with fabric, 87.9 x 84.7 cm.
Gift of Joey and Toby Tanenbaum, 1995 (Inv. 95/143)

The Játiva Master, also known as the Master of the Seven Sorrows of the Virgin, was active in southeastern Spain in the last quarter of the 15th century. The name derives from the town of Játiva (Xàtiva) in the province of València where several works can be found by this artist's hand, including *The Seven Sorrows of the Virgin* in the Church of Saint Francis. The Játiva Master took a traditional approach, close to the Perea Master and the Artés Master, Spanish artists active c. 1490–1510, and favoured gold backgrounds and rich gilded draperies. The gold leaf in this work was applied using water gilding, a technique carried out before oil paint was applied to the surface. Gilded areas were marked off and the ground covered with bole (pigmented clay) that enhances the colour of the gold leaf laid on top. This approach offers a smooth surface conducive to later burnishing, when the areas are rubbed with a hard polished stone. In *The Crucifixion* the haloes and the brocade cloak on the right are also tooled with a metal stylus; this and the stippling, for which dots form the appearance of lines, effectively catch ambient light.

The abstracted geometry of the composition contrasts with the Játiva Master's more naturalistic approach to the faces, which express sadness and resignation. The two thieves flank Christ and their spirits appear anthropomorphized, attributed human form above their heads: one is led to heaven by an angel and the other to hell by an ominous looking demon. Unusual for Valencian painting of the period but characteristic of this artist's work is the detailed, rocky landscape and cityscape directly behind Christ. A similar approach can be found in *The Adoration of the Magi*, a work by the same artist in the Toledo Museum of Art (26.82), the only other Játiva Master panel known in North America. The verso of *The Crucifixion* panel shows a large v-shaped imprint to the bare wood that suggests it was part of a larger structure, likely a multi-panel altarpiece.

**Provenance**
Spain, Private Collection, before 1938
Monaco, Sotheby's, 17–18 June 1988, n. 803
Toronto, Joey and Toby Tanenbaum, 1988–1995

**Exhibition History**
Toronto, Art Gallery of Ontario, 1988–1992 (on long-term loan)

**Bibliography**
Post, Chandler Rathfon. *History of Spanish Painting: The Valencian School in the late Middle Ages and early Renaissance*. vol. 6 Cambridge: Harvard University Press, 1935.
Wittmann, Otto. *The Toledo Museum of Art: European Paintings*. University Park: Penn State University Press, 1976.

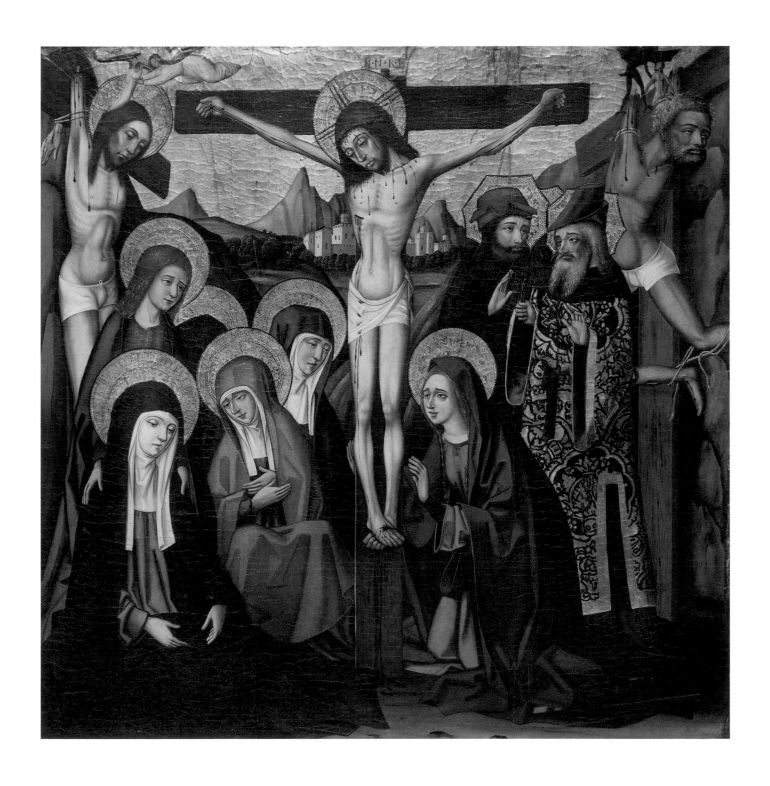

cat. 4 & 5

# Pseudo-Bles, attributed to (Flemish, active 1510–1530)

## *The Messengers with the Water Before David*
## *The Queen of Sheba visiting King Solomon*

c. 1515–1520, oil on panel, 55.4 x 26.4 cm; 55.5 x 26.4 cm
Gift of Dr. Anne Tanenbaum to the Government of Ontario, on long-term loan to the Art Gallery of Ontario, 1995
(AGOID.19525, 19536)

These two panel paintings were originally wings from an altarpiece. The left panel represents King David receiving his warriors who have brought him the water he requested from the well at the gate of Bethlehem, the city which was then occupied by the Philistines (2 Samuel 23:15–17). In this scene, an armour-clad warrior is about to kneel to present the container of water as David raises his hand to bless the gift. However instead of drinking the water, as it was expected he would do, King David declared it was the blood of the warriors who had risked their lives for the Israelites. He then poured it out in the Lord's name. The right panel illustrates a later subject when David's son, King Solomon, had finished constructing the Temple. The Queen of Sheba travelled from her kingdom (possibly Ethiopia or Yemen) on a state visit to Jerusalem. Sheba had heard of Solomon's wisdom and wealth and came "with a very great retinue, with camels bearing spices, and very much gold, and precious stones" (I Kings 10:1–13). She also came with questions and riddles and found that he could answer them all. We see Sheba dressed in her finery, kneeling before Solomon, and offering him a gold vessel. The theme of presenting gifts unites these two panels that originally flanked a central scene of the Adoration of the Magi, in which the three kings offer their gifts to the newborn Christ child. Precedents for the use of these subjects as commentary on the Adoration of the Magi subject can be found in illustrated typological books that relate the Old and New Testaments such as *Speculum Humanae Salvationis*, a fourteenth-century treatise that was translated from Latin into several vernacular languages. Another precedent was the *Biblia Pauperum*, "Pauper's Bibles," that were predominantly pictures and spread widely through printed editions in the late fifteenth century. Both of these sources appear to have been used for the David and Sheba panels.

The name Pseudo-Bles (or Pseudo-Blesius) has been assigned to a series of works that relate to the *Adoration of the Magi* painting (Munich, Alte Pinakotek, inv. 708), which had an apocryphal signature of Flemish artist Herri met de Bles (born c. 1510). An artist of the Southern Netherlands, the work of Pseudo-Bles exemplifies a flamboyant Late Gothic style known as Antwerp Mannerism. The exaggerated Gothic architecture represented in the background of the David and Sheba panels, as well as the cool tonalities used to depict the atmosphere around the cityscapes are characteristic of this school of Mannerism, as are the attenuated forms of the figures and the angularity of their gestures. This style of painting was practiced by artists in Antwerp from circa 1500 to 1530. Comparison with related works in the Prado Museum and the Art Institute of Chicago suggests that these panels originally had arch-like tops that were cut off at an unknown date.

### Provenance
Paris, Comtesse Edouard de Pourtalès
Pourtalès family
Paris, Hôtel Drouot, 21 November 1977, n. 8
Monaco, Sotheby's 2 December 1988, n. 617
Toronto, Dr. Anne Tanenbaum, 1988–1995

### Exhibition History
Bruges, Hôtel de Gouvernement Provincial, *Exposition des primitifs flamands et d'art ancien*, 15 June–15 September 1902, n. 277 (as Jan van Eyck)

### Bibliography
Born, Annick. "Antwerp Mannerism: a fashionable style?," *Jaarboek Koninklijk Museum voor Schone Kunsten Antwerpen* (2004/2005): 9–20.
Friedländer, Max Jacob. "Die Antwerpener Manieristen von 1520," *Jahrbuch der königlich preußischen Kunstsammlungen* vol. 36 (1915): 65–91.
-----. *Die niederländischen Manieristen*. Leipzig: E.A. Seemann, 1921.
-----. *Early Netherlandish Painting: The Antwerp Mannerists, Adriaen Ysenbrant*. Trans. Heinz Norden vol.11 New York: Praeger, 1974.
Glück, G. "Beiträge zur Geschichte der Antwerpener Malerei im XVI. Jahrhundert," *Jahrbuch der Kunsthistorischen Sammlungen des Allerhöchsten Kaiserhauses* vol. 22 (1901): 8.
Hulin de Loo, Georges. *Exposition de tableaux flamands des XIVe, XVe, et XVIIe siècles*. Gand: A. Siffer, 1902.
Michiels, Alfred. *Histoire de la peinture flamande depuis ses débuts jusqu'en 1864*. vol. 4 Paris: Librairie internationale, 1866.
Wolff, Martha. "Hebrew Kings and Antwerp Mannerists," in *Collected Opinions: Essays on Netherlandish Art in Honour of Alfred Bader.* eds. Volker Manuth and Axel Rüger. London: Holberton, 2004, 278–294.

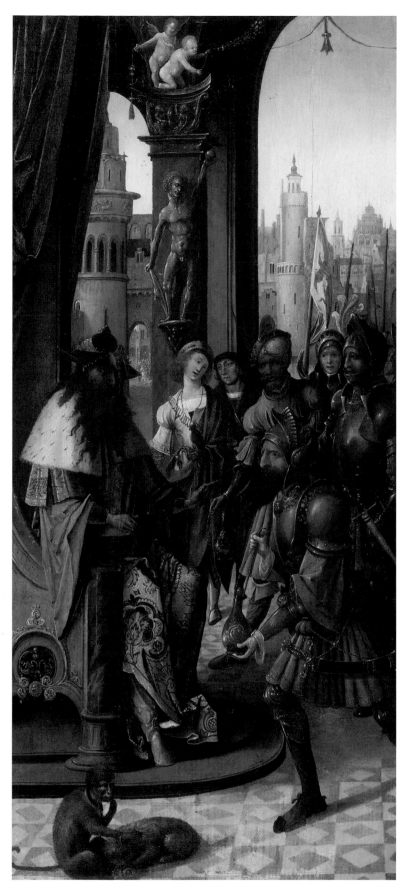
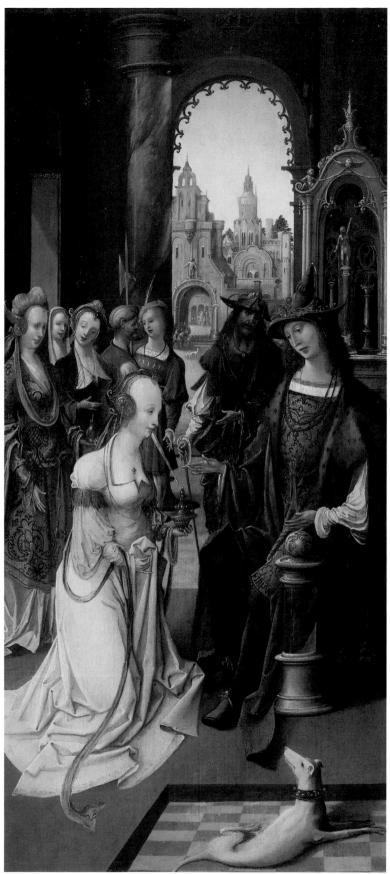

cat. 6

# Tomasso di Stefano Lunetti, attributed to (Italian, c. 1495–1564)

## *The Adoration of the Shepherds*

1520–1540, oil on panel, 75.6 x 49.5 cm
Gift of Joey and Toby Tanenbaum, 1985 (Inv. 85/313)

At the foot of architectural ruins, two shepherds arrive and kneel before the Christ Child, who is accompanied by the Virgin Mary, Joseph, two angels, and two animals, an ox and a donkey. In the middleground on the right, we witness an earlier moment in the narrative: the shepherds tend their flock and an angel appears to them announcing the birth of Christ, who they are told they will find lying in a manger in Bethlehem. The subject of the adoration (Luke 2: 8–20) can be found in Western European art from the end of the fifteenth century and was popular through the seventeenth century. Lunetti presents a composition that is visually balanced around the body of a quite ordinary looking Christ Child. Christ lies on a blanket with his head supported by a sheaf of wheat, a symbol of the Eucharist. Above the principal scene, a colourful collection of angels hover in perpetual adoration and represent the heavens above. Between the angels and the heads of the lower shepherds we detect a procession approaching, which is likely the three Magi and their retinue. Lunetti displays his talents for aerial perspective in the cool blue and grey tonalities that fade and become atmospheric in the distant landscape.

This painting is attributed to Tomasso di Stefano Lunetti, painter, architect, miniaturist and producer of *drappelloni*, elaborate hangings for festivals and ceremonies. He was the son of Florentine painter and architect Stefano di Tomasso di Giovanni Lunetti, who was a close friend of Lorenzo di Credi, with whom Giorgio Vasari states the son apprenticed. The only known signed painting by Lunetti is a *Portrait of a Man* from 1521 in the Metropolitan Museum of Art (17.190.8). Vasari also noted an *Adoration of the Shepherds*, formerly in the Villa Capponi in Arcetri, that is now in a private collection in Italy. Lunetti was likely inspired by the central panel of Hugo van der Goes's *Portinari altarpiece* that was painted in Bruges around 1475 and hung in Florence from 1483 in the church of San Egidio (now Uffizi Gallery). There are similarities in poses although Lunetti pared down the number of figures in his composition and simplified their dress. He likely produced this work for a private patron.

Provenance records for this work suggest the Duke of Wellington received the painting as a gift from King Ferdinand VII of Spain in recognition for Wellington's

role in the Battle of Vitoria in 1813. Wellington led an allied British, Spanish and Portuguese army against the French army and Joseph Bonaparte, whom Napoléon I had appointed King of Spain 1808–1813.

### Provenance

Spain, Collection of King Ferdinand VII in 1813
London, Apsley House, Collection of the Duke of Wellington, 1813–1979 (attributed to Sogliani)
London, Christie's, 29 June 1979, n. 79
London, Norman Leitman
Toronto, Joey and Toby Tanenbaum, 1985

### Bibliography

Berenson, Bernard. *Italian Pictures of the Renaissance: Florentine School*. vol.1 New York: Phaidon, 1963.

Costamagna, Philippe and Anne Fabre. "Un ritratto di Tommaso di Stefano agli Uffizi," *Prospettiva* vol.40 (January 1985): 72–74.

Degenhart, Bernhard. "Die schülder des Lorenzo di Credi," *Münchner Jahrbuch der Bildenden Kunst* n. s. 9 (1932): 95–161.

Russell, Francis. "Drawings by Tommaso di Stefano Lunetti and Ridolfo Ghirlandaio," *Master Drawings* vol.27 n. 3 (Autumn 1989): 228.

Tamborino, Alessandra. "Non Michelangelo ma Tommaso di Stefano Lunetti. Gli affreschi di Santa Maria a Marcialla," *Paragone* n. 72 (March 2007): 43–54.

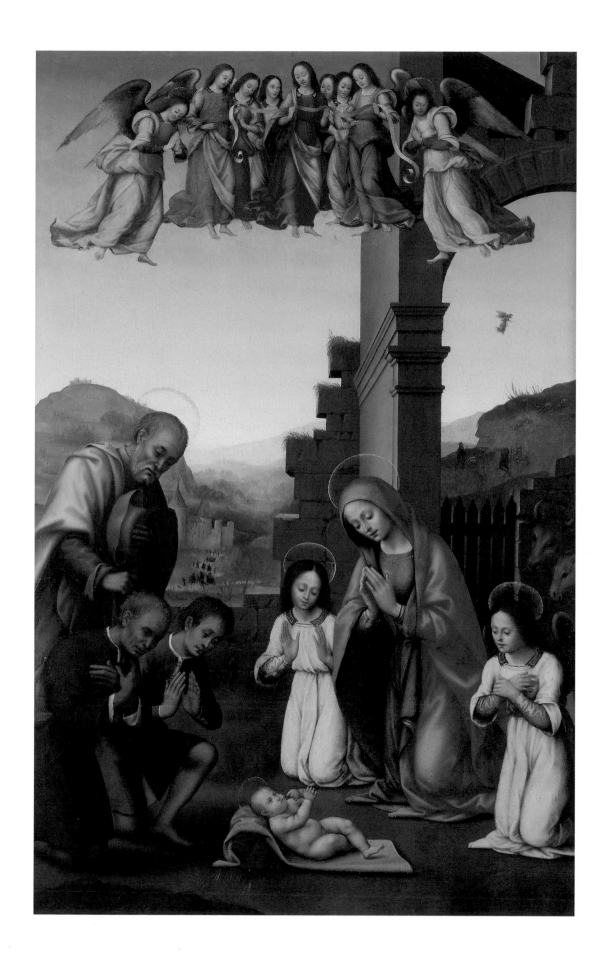

# Pieter Claeissens the elder, attributed to (Flemish, 1499/1500–1576)

## *Moses breaking Pharaoh's Crown*

c. 1530–1572, oil on panel, 127.2 x 177.9 cm
Gift of Joey and Toby Tanenbaum, 1995 (Inv. 95/138)

The Pharaoh's crown lies shattered in the middle of the stone floor where it was thrown by Moses, then a child, who stands next to the pieces and eats a burning ember offered to him by a servant. The latter act proves to all present that he has God's favour and he is thus saved from execution. Indeed, one of the armed guards is about to unsheathe his sword as the Pharaoh sits on an intricately carved throne and is warned by his advisors that this event foreshadows the impending destruction of Egypt. This dramatic scene is flanked by other significant moments in Moses' life. On the left, the servant of the Pharaoh's daughter discovers an abandoned baby Moses in a basket. On the right are events that will occur later in his life. In the foreground, the Pharaoh's army drowns in the powerful waters of the Red Sea as it closes over them. Behind that, the Israelites pass through the desert and worship false idols — represented by the sculpted calf transported high on a green plinth. In the small figural grouping at the rear, Moses and his hungry companions witness white wafers falling from heaven, which they called manna. While those familiar narratives are recounted in Exodus and Numbers, the central subject of this work is an apocryphal story that originates in Josephus Flavius' *Antiquitate judaica* and dates to the late 1st century CE. From there, it entered Christian literature and was recounted in manuscripts and other sources throughout the Middle Ages. Representations such as this from the Renaissance period are more rare and the three-part structure of this composition relates to the traditional format of the triptych. The poses of several soldiers and the elaborate drapery, such as the dress of the principal female figure, suggest Claeissens' debt to both classical sources and Renaissance models.

*Moses breaking Pharaoh's Crown* is attributed to Claeissens the elder, who belonged to a Flemish family of artists based in Bruges. His three sons were also painters. Pieter Claeissins the elder studied with Adrian Becaert in 1516 and became a master of the Bruges Guild of St. Luke in 1530. Claeissens the elder held several posts in the guild. He was also an illuminator and portraitist, and in 1572 he was commissioned to paint a *Resurrection* for the Cathedral in Bruges that remains *in situ*. Although there are no known signed works by Claeissins the elder, he was also commissioned in 1567 to paint a *Crucifixion* for the Augustinian Church in Bruges;

this work and others attributed to him on the basis of their analogous style are now in the Groeningemuseum in Bruges. *Moses breaking Pharaoh's Crown* is stylistically similar to the *Mass of Saint Gregory* that is in the collection of the Sarah Campbell Blaffer Foundation in Houston.

**Provenance**

Brussels, Étienne van Houtte
Brussels, Kervyn de Lettenhove
Brussels, Private Collection
New York, Jack Kilgore & Co.
Toronto, Joey and Toby Tanenbaum, 1994–1995

**Bibliography**

Michiels, Alfred. *Les Peintres brugeois*. Brussels: A. Vandale, 1846.
Weale, William Henry James "A Family of Flemish Painters," *Burlington Magazine* vol. 19 (July 1911): 198–204.
-----. "Peintres brugeois: les Claeissins (1500–1656)," *Annales de la Société d'émulation de Bruges* vol. 61 (1911): 26–76.
Wilson, Jean C. *Painting in Bruges at the close of the Middle Ages: Studies in Society and Visual Culture*. University Park: Penn State University Press, 1998.

cat. 7

**Pieter Claeissens the elder,
attributed to**
*Moses breaking Pharaoh's Crown*

cat. 8

# **Unknown Artist** (Flemish [?], late 16th-early 17th century)

## *The Raising of Lazarus*

c. 1580–1630, oil on panel, 74.4 x 105.8 cm
Gift of Joey and Toby Tanenbaum, 1995 (Inv. 95/149)

Lazarus, brother of Mary Magdalene and Martha, had been dead for four days before Christ's arrival in Bethany. In one of the miracles connected with Christ's life (John 11:1–44), he visited the grave, asked for the stone to be removed from its opening, and called out "Lazarus, come forth." It is the moment of Christ's declaration of faith that we witness in this work. Christ's mouth remains slightly open and he raises his hand inviting Lazarus back into the world of the living. Lazarus emerges still partially wrapped in the linen cloth that had enveloped his corpse. Mary and Martha kneel at Christ's side while a crowd of spectators expresses a range of responses from awe and disbelief to reverence and devotion. The numerous rhetorical gestures manifest by figures across the composition reinforce the momentary quality of the miraculous event. The mystery of Lazarus' return to life symbolized the promise of the resurrection of all humanity at the Last Judgment.

The composition is crowded and lit with strong lighting that sets off the figures in exotic dress, most of whom are set in a shallow stage-like space in the foreground. Between Christ and Lazarus, an empty space recedes into a background and draws the viewer's attention to the Classical ruins. Several figures, such as the two men in the upper right corner and those supporting Lazarus, twist and form a complex intersection of limbs that is often seen in Mannerist works. Stylistically this painting relates to late Mannerism and was done after a work by Italian artist Giuseppe Cesari, Cavaliere d'Arpino (1568–1640), now in the collection of the Galleria Nazionale d'Arte antica in the palazzo Barberini, Rome (Inv. 41), which in turn relates to depictions of the subject by Federico Zuccaro (engraved by Cornelius Cort), Girolamo Muziano, and Taddeo Zuccaro. D'Arpino's composition was much admired and several copies were made, including one in the Musée de Tours. These works inspired awe and faith in the viewer and their relatively small scale suggests they were intended for private devotion.

**Provenance**

Basel, Rüsch-Burckhardt Collection, in 1932 (attributed to Frans Franken I)
Private Collection
London, Sotheby's, 8 December 1993, n. 254 (attributed to Marten Pepyn)
Toronto, Joey and Toby Tanenbaum, 1993–1995

**Bibliography**

Bayer, Thomas M. "The Artist as Patron: An Examination of the Supervisory and Patronal Activities of Giuseppe Cesari, The Cavaliere d'Arpino," *Athanor* vol. 9 (1990): 17–23.

Röttgen, Herwarth. *Il Cavalier Giuseppe Cesari d'Arpino: un grande pittore nella splendore della fama e nell'inconstanza della fortuna.* Rome: Ugo Bozzi, 2002.

-----. *Il Cavalier d'Arpino.* Rome: De Luca, 1973.

Spear, Richard E. "The 'Raising of Lazarus': Caravaggio and the Sixteenth Century Tradition," *Gazette des Beaux-Arts* vol. 65 n. 1153 (February 1965): 65–70.

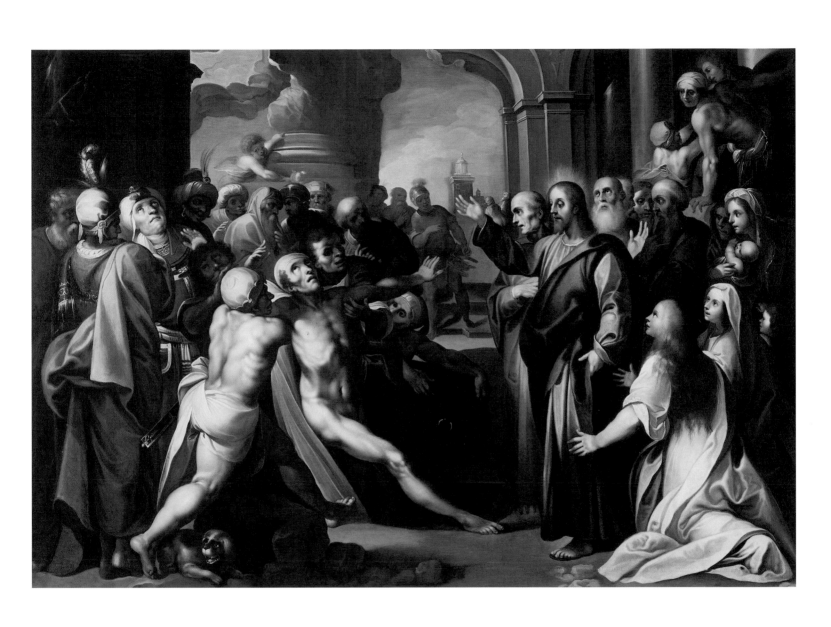

# **Tobias Verhaecht** (Flemish, 1561–1631)

## *Mountain Landscape with Figures*

c. 1590–1630, oil on panel, 45.9 x 66.9 cm
Gift of Joey and Toby Tanenbaum, 1995 (Inv. 95/151)

Verhaecht produced imaginary landscapes, typically with panoramas of mountains and uninhabited rocky outcroppings. This contrasts with his more realistic approach in the foreground, which is populated with numerous figures and anecdotal details. Shepherds tend their sheep and converse, as do men who gesture animatedly in the streetscape. At the base of a complex tower edifice, a woman does her washing while a child watches from underneath a protective canopy. Many men appear to be soldiers: several wear reflective helmets and some carry shields and spears. A group of these soldiers gathers in lively discussion next to an authoritative looking man on horseback. Nearby, a dog emerges from the forest and a man with crutches sits at the edge of the busy path. While we do not witness any dramatic event, the descriptive details lead our eyes through a composition that is clearly divided into three parts: the tower and environs, the townscape, and the distant landscape. Verhaecht's precise application of paint activates the canvas, for example the rustling leaves and the coursing water. He also creates a sense of contrasting textures between the brick, wood, and thatching that forms the tower and its ancillary structures. The tower intersects with the fantastical and atmospheric background that is dominated by cool shades of grey and blue. Verhaecht's approach to landscape painting connects him with an earlier tradition, particularly Pieter Brueghel I, whose work was disseminated through large engravings.

This painting may be an early work, but is stylistically close to canvases produced between 1612 and 1623, the period of all of Verhaecht's known dated works. Verhaecht was active primarily in Antwerp, where he became a master of the Guild of St. Luke in 1590. Before that, he worked in Italy, both in Rome where he had a reputation for painting landscape frescoes, and in Florence where he attracted the interest of Francesco I, Grand Duke of Tuscany (r.1574–1587). In Antwerp, Verhaecht was active both as a painter and as a member of the chamber of rhetoricians, and wrote a comedy. He had several pupils, including Rubens briefly, and in 1594 was commissioned to design the decorations for the triumphal entry of Archduke Ernest of Hungary into Antwerp.

**Provenance**

London, Norman Leitman and Todd Butler
Toronto, Joey and Toby Tanenbaum, 1988–1995

**Exhibition History**

Toronto, Art Gallery of Ontario, 1988–1990 (on long-term loan)

**Bibliography**

Boerlin, Paul Henry. "Bilder zwischen Imagination und Wirklichkeit: zu zwei Alpenlandschaften von Tobias Verhaecht," *Unsere Kunstdenkmäler* vol. 24 (1974): 267–274.

Liederkerke, Anne-Claire de. *Fiamminghi a Roma: artistes des Pays-Bas et de la principauté de Liège à Rome à la Renaissance.* Ghent: Snoeck-Ducaju & Zoon, 1995.

Roey, J. Van. "De eerste leermeester van P. P. Rubens: Tobias van Haecht," *De Rederijker* (November–December 1977).

Spicer, Joaneath. "Tobias Verhaecht," in *Dutch and Flemish Drawings from the National Gallery of Canada.* Ottawa: National Gallery of Canada, 2004, 66–67.

Thiéry, Yvonne. *Le paysage flamand au XVIIe siècle.* Paris: Elsevier, 1953.

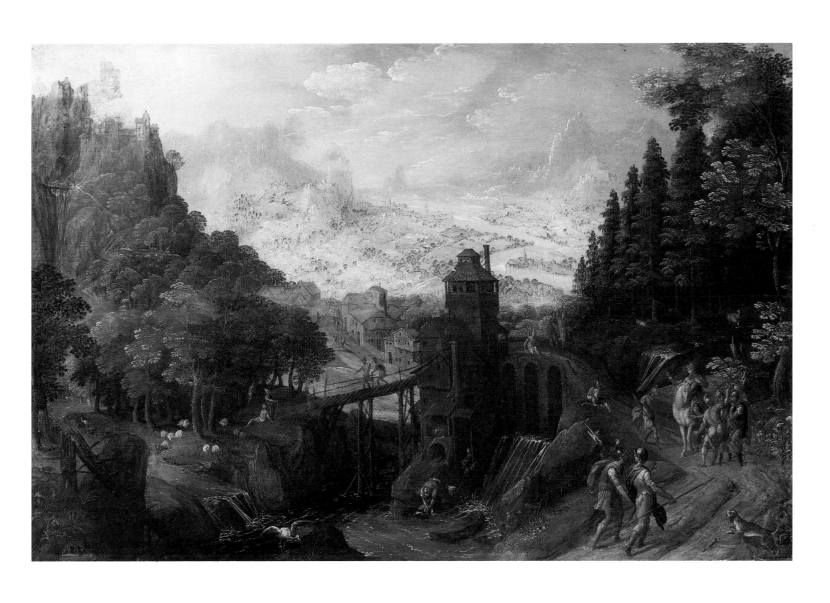

cat. 10

# Jan Brueghel the Elder (Flemish, 1568–1625)
# Hans Rottenhammer (German, 1564/65–1625)

## *Allegory of Life ("The Dream of Raphael")*

1595, oil on copper, 35.6 x 51.4 cm
s.d.l.r. BRVEGHEL 1595
inscribed below the man on the left: SEDET AETERNUM QUE SEDEBIT IFOELIX and below the woman on the right:
TV NE CEDE MALIS SED COTRA AVDENTIOR ITO
Gift of Joey and Toby Tanenbaum, in loving memory of Max Tanenbaum, 1986 (Inv. 86/238)

This painting is based on an engraving dated 1561 by Italian Mannerist artist Giorgio Ghisi (1520–1586) that is traditionally entitled *The Dream of Raphael* (or *Michelangelo's Melancholia*). This work has been identified by the same title, however *Allegory of Life* is now generally accepted as a more accurate description of the subject. The iconography of this work is enigmatic and evokes various themes. Our attention is immediately drawn to the hermit-like man surrounded by various beasts: a leopard, jackal, rooster, serpent, winged dragon and chimera populate nature with a centaur further in the distance. The male figure has withdrawn from worldly concerns and meditates near a tree that, with the absence of foliage, suggests dormancy. A gesturing female figure, accompanied by a peacock, enters the composition while drapery billows around her. Four putti float playfully above her head and one crowns her with flowers. More flowers populate the landscape around her. These symbols intimate springtime, passion, and an active life. Inscriptions that are also based on Ghisi can be seen below these figures and quote Virgil's *Aeneid* (Book VI). Below the man reads: SEDET AETERNUM QUE SEDEBIT IFOELIX (verse 617: wretched he [Theseus] sits still, and will sit for eternity], and below the woman: TV NE CEDE MALIS SED COTRA AVDENTIOR ITO (verse 95: do not give way to misfortunes, meet them more bravely). These two principal figures and their symbols evoke comparisons between passion and reason, or active and contemplative lives. They are separated by a lively flow of water, in which a leviathan coils his tail around a victim one presumes was taken from the nearby boat. Brughel depicts the landscape in all its animated diversity. His vibrant use of colour and attention to microscopic detail captures the transcendence of nature.

Jan Brueghel was born in Brussels and he is often called "Velvet", "Flower" or "Paradise Brueghel" to differentiate him from his father Pieter Brueghel the Elder, his brother Pieter Brueghel the Younger, and his son Jan Brueghel the Younger. Brueghel produced *Allegory of Life* in 1595 when he was closely connected to Cardinal Federico Borromeo,

a post-Tridentine reformer and founder of the Pinacoteca Ambrosiana in Milan, who became his patron in the early 1590s. Brueghel lived with Borromeo first in Rome and then Milan until he left for Antwerp in May 1596 where he soon became dean of the Guild of St. Luke. Ghisi's engraving could well have been in Borromeo's collection and Brueghel's patron may have requested it as the basis for a commission; three quarters of the works in Borromeo's collection at this time were by Flemish artists and, of those, Brueghel and Paul Bril were the best represented. Brueghel also played a significant role in helping Borromeo develop his print collection. Rottenhammer executed the figures for this work; he and Brueghel met in Italy and they collaborated on several occasions. The painting is typical of Brueghel's earlier landscapes in which he divides the composition into three distinct planes that are distinguished by their representation of light and the predominance of one colour. *Allegory of Life* manifests both Italian classicism and a northern style of painting that is predicated on the heightened level of detail and the apparent naturalism of the composition.

## Provenance

London, Ralph's Exhibition of Pictures, 1791, n. 18 (Joshua Reynold's sale)
London, Christie's, 28 June 1811, n. 62 (Beresford sale; as Breughel *Breughel's Dream*)
London, Rowland Gorrings, 24 October 1929 (E.P. Warren sale; as Brueghel *The Melancholy of Michelangelo*)
London, Christie's, 17 March 1944, n. 11 (H. Asa Thomas sale; as Brueghel *Circe Calling Ulysses*; sold with photograph of engraving *The Melancholy of Michelangelo*)
London, Sotheby's, 25 June 1969, n. 87 (Salomon van Berg sale; as Brueghel and Van Balen *Raphel's Dream*)
London, Sotheby's, 12 December 1979, n. 21 (Leggatt sale; as Brueghel and Rottenhammer *Raphael's Dream*)
Toronto, Joey and Toby Tanenbaum, 1986

## Exhibition History

Vienna, Kunsthistorisches Museum, 9 December 1997–14 April 1998; Antwerp, Royal Museum of Fine Arts, 2 May–26 July 1998: *Breughel Brueghel* (as *Circe and Ulysse*), cat. 69

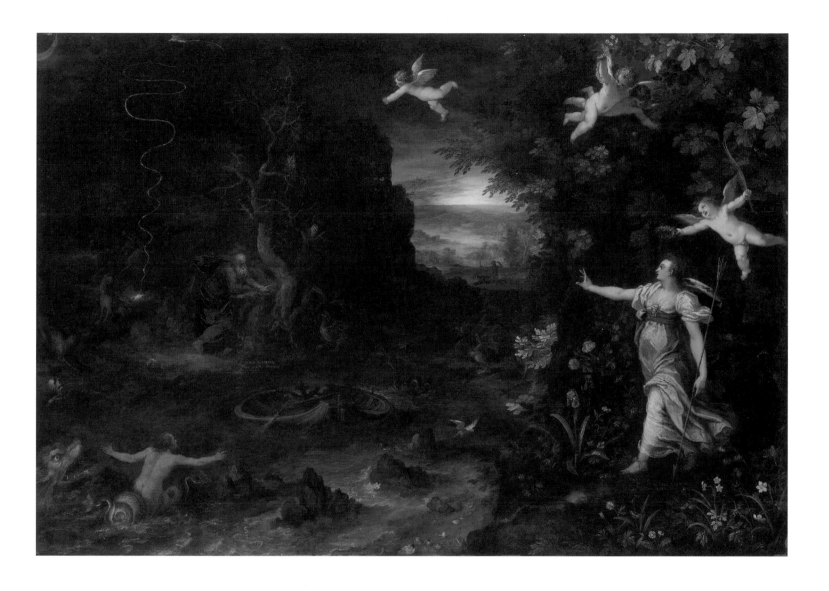

**Bibliography**

Albricci, Gioconda. "Il 'Sogno di Raffaello' di Giorgio Ghisi," *Arte Christiana* vol. 71 (July-August 1983).

Bedoni, Stefania. *Jan Brueghel in Italia e il Collezionismo del Seicento*. Florence: [Bedoni], 1983.

Boorsch, Suzanne. *The Engravings of Giorgio Ghisi*. New York: Metropolitan Museum of Art, 1985.

Ertz, Klaus. *Jan Brueghel der Ältere (1568–1625): Die Gemälde mit kritischen Ouvrekatalog*. Cologne: Dumont Buchverlag, 1979.

Ertz, Klaus et al. *Breughel-Brueghel: Pieter Breughel le Jeune (1564–1637/8) et Jan Brueghel l'Ancien (1568–1625), une famille des peintres flamands vers 1600*. Lingen: Luca Verlag, 1998.

Jones, Pamela M. *Federico Borromeo and the Ambrosiana: Art Patronage and Reform in Seventeenth-Century Milan*. Cambridge: Cambridge University Press, 1993.

Zerner, Henri. "Ghisi et la gravure maniériste à Mantoue," *L'Oeil* vol. 88 (April 1962): 26–33, 76.

# Jusepe de Ribera (Spanish, 1588/91–1652)

## Saint Jerome

1614–1615, oil on canvas, 125.7 x 99.5 cm
Signed on the spine of the closed book: "JOSEPHVS, RIBERA, VALETINVS CIVITATIS SETABIS HISPANVS/ME FECIT"
Gift of Joey and Toby Tanenbaum, 1995 (Inv. 95/150)

Born Eusebius Hieronymus Sophronius (342–420) in Dalmatia, east of the Adriatic ocean (today Croatia), Jerome was declared a saint soon after his death. As one of the Latin Fathers of the Church, Jerome is presented by Ribera as having many distinguishing features. Surrounded by papers and with pen in hand, he is shown as a scholar engaged in important work translating the Old and New Testaments. The Council of Trent (1545–63) declared this translation, known as the *Vulgate*, the official Latin version of the bible in the Roman Catholic Church. A new edition of the Vulgate published in 1592 for Clement VIII offers a specific context for this painting by Ribera. Jerome appears as a hermit who has withdrawn from the outside world, an old man with grey hair and beard, partially naked and unkempt. The shadowy form of a skull behind Jerome's hands signifies both his contemplative nature and the transience of life. What appears as red drapery casually wrapped around Jerome's nude torso is actually his cardinal's robe. Although Jerome was never made a cardinal he held an appointment under Pope Damascus I whereby he was known as a Doctor of the Church, so is often portrayed with cardinal's robes in recognition of his theological contributions.

In this early work Ribera's definition of Jerome's emaciated yet muscular form exemplifies his technical skills, particularly his draughtsmanship. The descriptive details of his wrinkled face and hands are also characteristic of Ribera's vibrant realism. Light shining from outside the frame of the painting bathes Jerome's body and casts a luminous glow to his golden flesh. The composition and lighting demonstrate the significance of Caravaggio on Ribera's work. Ribera set Jerome dramatically before a blank background and created tonal harmony between the figure and his attributes, particularly the worn leather bound book and skull. The quill pen and ragged sheets of paper add important highlights to the composition. Although Spanish, Ribera spent his career in Italy and was one of the most important artists of the Baroque period. This work has been identified as Ribera's earliest signed painting. He wrote across the spine of the closed book "Josephus Ribera, Valencian, from the city of Játiva, Spaniard, made this work." Ribera joined the Academia di San Luca in Rome in 1613 and typically referred to his membership in works signed after this date. Recent scholarship, however, suggests this was not always the case and dates this painting to 1614–1615. In 1616 Ribera moved to the Kingdom of Naples, which was then part of the Spanish empire. There he enjoyed the patronage of several Spanish viceroys and also received commissions from Cosimo II, Grand Duke of Tuscany. In 1626 his talent was recognized when he received a Vatican order of nobility, the Croce di Cavaliere dell'Ordine di Cristo. Ribera was particularly significant in the context of the Counter-Reformation and this painting of Jerome ranks among his most evocative half-length images of saints.

### Provenance

Princes of Bourbon, Sicily, and Naples to 1861/62
Private Collection
New York, Habsburg, Feldman, 9 January 1990, n. 49
Toronto, Joey and Toby Tanenbaum, 1990–1995

### Exhibition History

New York, Metropolitan Museum of Art, 18 September–29 November 1992; Naples, Castel Sant'Elmo, 27 February–17 May 1992, n. 13; Madrid, Museo del Prado, 18 May–9 August 1992, *Jusepe de Ribera 1591–1652*, cat.6
Madrid, Museo del Prado, 5 April–31 July 2011, *El joven Ribera*, cat. 10
Ottawa, National Gallery of Canada, 17 June–11 September 2011; Fort Worth, Kimball Art Museum, 9 October 2011–8 January 2012, *Caravaggio and his followers in Rome*, cat. 35

### Bibliography

Felton, Craig. "Out of the Shadows: Jusepe de Ribera," *Apollo* vol.136 (September 1992): 143.
-----. "Marcantonio Doria and Jusepe de Ribera's Early Commissions in Naples," in *Ricerche sul '600 napolitano.* ed. Gennaro Borelli. Milan: Lanconelli & Tognolli, 1991, 123–139.
Milicua, José and Javier Portús et al. *El joven Ribera*. Madrid: Museo del Prado, 2011.
Papi, Gianni. *Ribera a Roma.* Soncino: Edizioni dei Soncino, 2007.
-----. "Jusepe de Ribera a Roma e il Maestro del Giudizio di Salomene," *Paragone* vol. 44 (2002): 21–43.
Pérez Sánchez, Alfonso E. and Nicola Spinosa. *Jusepe de Ribera 1591–1652.* New York: The Metropolitan Museum of Art, 1992.
Spinosa, Nicola. *Ribera. La obra completa.* Madrid: Fundación Arte Hispánico, 2008.
-----. *Ribera. L'opera completa.* Naples: Electa, 2003.

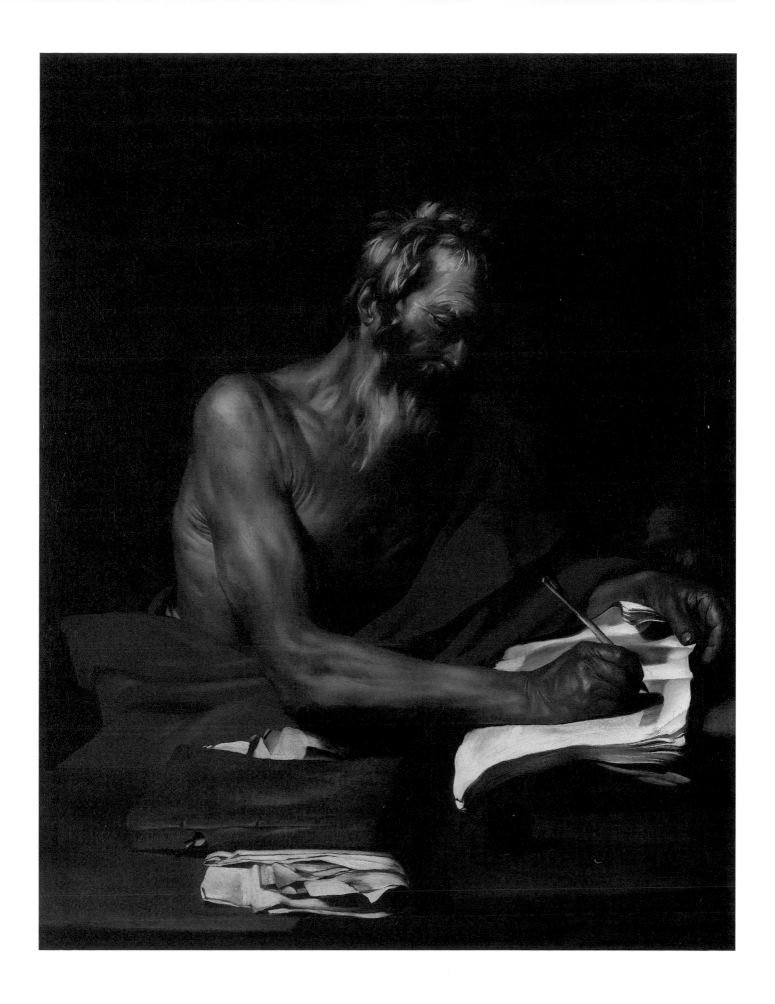

# Artus Wolffort (Flemish, 1581–1641)

## Saint Bartholomew

c. 1616, oil on canvas, 115.2 x 98.5 cm
Gift of Joey and Toby Tanenbaum, 1995 (Inv. 95/152)

Saint Bartholomew appears in this work as a devout ascetic reading the scriptures in a remote cave-like setting. A feature of much Baroque art, light enters the work from an external source and highlights parts of Bartholomew's head and face. A more stark, full light bathes his book and hands, which are clasped in prayer. Light also reflects on the metallic surface of the knife placed directly below his hands, and the instrument signifies his martyrdom by being flayed alive because he refused to worship idols. The trompe l'oeil stone cartouche at the bottom edge of the composition includes a passage from the Apostles' Creed: he ascended to heaven and sits at the right hand of God the father almighty. Bartholomew was one of the original apostles, however much of his life is known only through the *Golden Legend*, a popular 13th-century book on the lives of saints written by Jacobus de Voragine. Wolffort focuses on Bartholomew's piety and the solitary nature of his pursuits; indeed Voragine recounts that he was a missionary in India and died in Armenia.

*Saint Bartholomew* is part of a series of twelve paintings of the Apostles, each depicted half-length. The Roman numeral in the cartouche indicates the order of the painting within the series. This work was placed sixth in the series. The inscriptions connected each of the historical figures with Christ as well as texts that were central to Roman Catholicism in the Counter-Reformation period. Wolffort had an active studio in Antwerp and, in addition to his series of the *Twelve Apostles*, he painted the *Four Evangelists* and *Four Fathers of the Church* following a similar half life-size format. Wolffort intended these works both for the open market and private use. Paintings such as these encouraged personal devotion and supported the theological traditions and thus the authority of the Roman Catholic Church. Research on Wolffort has evolved and the views of scholars have changed considerably in recent decades; he is now regarded as a notable artist in the circle of Rubens.

**Provenance**

London, Mrs. D. Scarisbrick, 1981
Private Collection
New York, Christie's, 31 May 1991, n. 43
Toronto, Joey and Toby Tanenbaum, 1991–1995

**Bibliography**

Auwera, Joost Vander. "Afgemeten, ingelijst en opgelijst. Kanttekeningen bij enkele aanvullingen op het oeuvre van Artus Wolffort (Antwerpen 1581–1641)," in *Munuscula Amicorum: Contributions on Rubens and his colleagues in honour of Hans Vlieghe*. Ed. Katlijne Van der Stighelen. Turnhout: Brepols, 2006, 593–612.

Held, Julius S. "Noch einmal Artus Wolffort," *Wallraf-Richartz-Jahrbuch* vol. 42 (1981): 143–56.

Vlieghe, Hans. "Zwischen van Veen und Rubens: Artus Wolffort (1581–1641), ein vergessener Antwerpener Maler," *Wallraf-Richartz-Jahrbuch* vol. 39 (1977): 93–136.

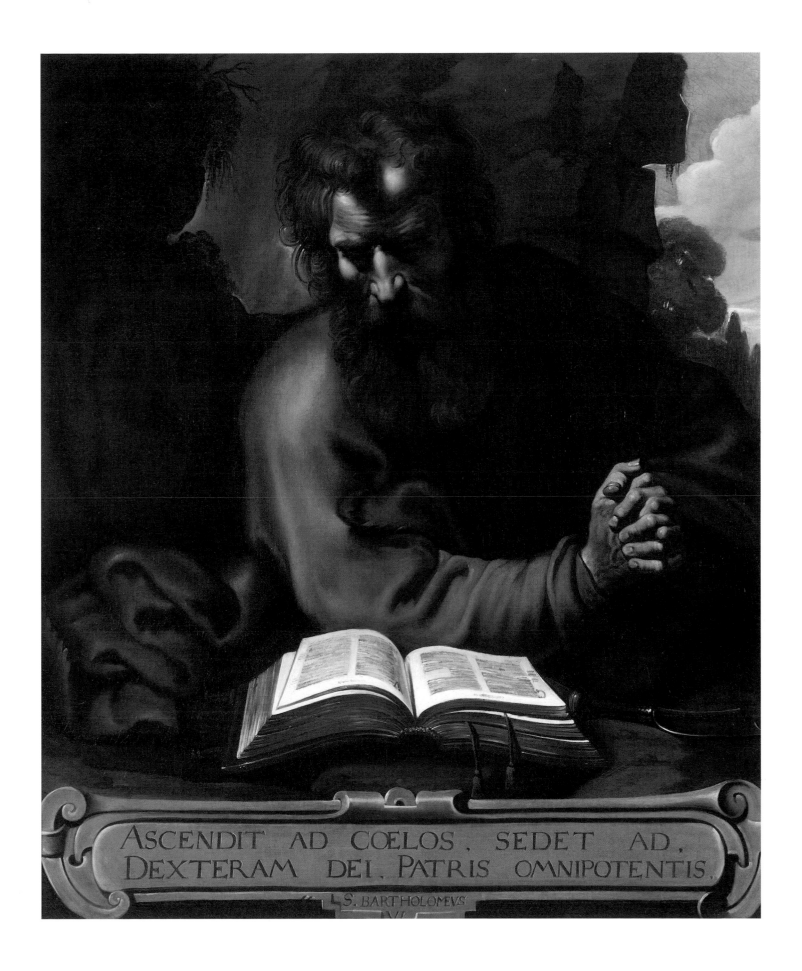

ASCENDIT AD COELOS, SEDET AD,
DEXTERAM DEI, PATRIS OMNIPOTENTIS,

S. BARTHOLOMEVS

cat. 13

# Gian Lorenzo Bernini (Italian, 1598–1680)

## *Pope Gregory XV*

1621, marble, 83.2 x 62.3 x 32.4 cm
Gift of Joey and Toby Tanenbaum, 1997 (Inv. 97/152)

Bernini masterfully unites the visual and emotional and this bust glows as if it were lit from within. Pope Gregory XV appears dressed for a ceremonial procession. He wears a linen amice, originally a hood that forms a collar enveloping his neck, underneath an alb, the sleeved robe gathered at his chest with an ornate trim, and a cope, the ecclesiastical cloak fastened with an embellished morse. On either side of the cloak are the apostles and saints Peter and Paul, the joint founders of the Church and who, when presented as a pair, represents its Jewish and gentile elements. Peter holds the keys of the kingdom of heaven, symbolizing his power to give absolution and to excommunicate, and a book that signifies his preaching of the gospel. Paul carries the sword with which he was executed and a book, refering to his authorship of the Epistles. The descriptive details of the heavy embroidering and decorative patterns add to Gregory's majestic appearance as head of the Roman Catholic Church and a direct successor to Saint Peter. At sixty-seven years of age Bernini presents Gregory leaning forward and slightly stooped either by the effects of age or the palpable weight of his office that is manifest in his vestments. Bernini depicts Gregory tilting his head up slightly and in the midst of speaking: his mouth is partially open and the lines on his forehead and the furrow in his brow concretize the emotion of his words. Bernini further activates Gregory's face with the dense tufts of his beard and the drillwork of the pope's penetrating eyes. In this highly successful bust, Bernini achieves a balance between animating the physiognomy and conveying the pope with a degree of formality and reserve appropriate to his station.

Alessandro Ludovisi (1554–1623) was elected Pope Gregory XV on February 9th, 1621 and while he held the position for only two years he was a significant figure. Under his leadership many important Counter-Reformation saints were canonized including Teresa of Avila, Ignatius of Loyola, Philip Neri, and Francis Xavier. Pope Gregory XV also brought about meaningful reform within the Catholic church when he instituted secret balloting in the election of future popes. This bust was commissioned immediately following Gregory's own election and he knighted Bernini later the same year when the artist was only twenty-three years of age. This early work was such a success that several bronze casts were made, one of which was acquired by Cardinal Scipione Borghese, who was among Bernini's most important patrons and commissioned some of his most significant early works including *Apollo and Daphne* (1622–25) and *David* (1623–24). The bronze castings of *Pope Gregory XV* are now in the collections of the Musée Jacquemart-André in Paris, the Statens Museum for Kunst in Copenhagen, and the Carnegie Institute in Pittsburgh.

Bernini was the leading sculptor of the seventeeth century and worked primarily in Rome where, in addition to Gregory XV, he enjoyed the patronage of numerous popes: Paul V, Urban VIII, Alexander VII, and Clement IX. He received further commissions from private families, such as the Cornaros for whom Bernini created one of the principal works of the Baroque era, *St. Theresa in Ecstacy* and the Cornaro chapel at Santa Maria della Vittoria (1645–52). Bernini was also a prominent architect who designed the piazza and colonnade of St. Peter's (1656–67) as well as the *Church of Sant'Andrea al Quirinale* (1658–61).

**Provenance**

Pope Gregory XV
Cardinal Ludovico Ludovisi
Rome, Casino Villa Ludovisi
Rome, Ludovisi family
Leicestershire, Swithland Hall, Earls of Lanesborough
    (acquired in Rome c. 1850)
London, Christie's, 17 October 1978 (as anonymous)
London, Nicholas Meinertzhagen
London, Sotheby's, 11 December 1980 (attributed to Bernini)
London, Norman Leitman
Toronto, Joey and Toby Tanenbaum, 1980–1997
New York, Christie's, 10 January 1990, n. 201 (offered)

**Exhibition History**

London, Vitoria and Albert Museum, 1978–1980
Fort Worth, Kimbell Art Museum, *The Art of Gianlorenzo Bernini: Selected Sculpture*, 1 April–16 May 1982, n. 13
Toronto, Art Gallery of Ontario, 1983–1986 (on long-term loan)
Toronto, Art Gallery of Ontario, 3 October–30 November 1986, *Vatican Splendour: Masterpieces of Baroque Art*, n. 13
Toronto, Art Gallery of Ontario, 1987–1989 (on long-term loan)
Edinburgh, National Gallery of Scotland, 1991–1994 (on long-term loan)
Rome, Palazzo Venezia, 21 May–16 September 1999, *Gian Lorenzo Bernini: regista del Barocco*, n. 41

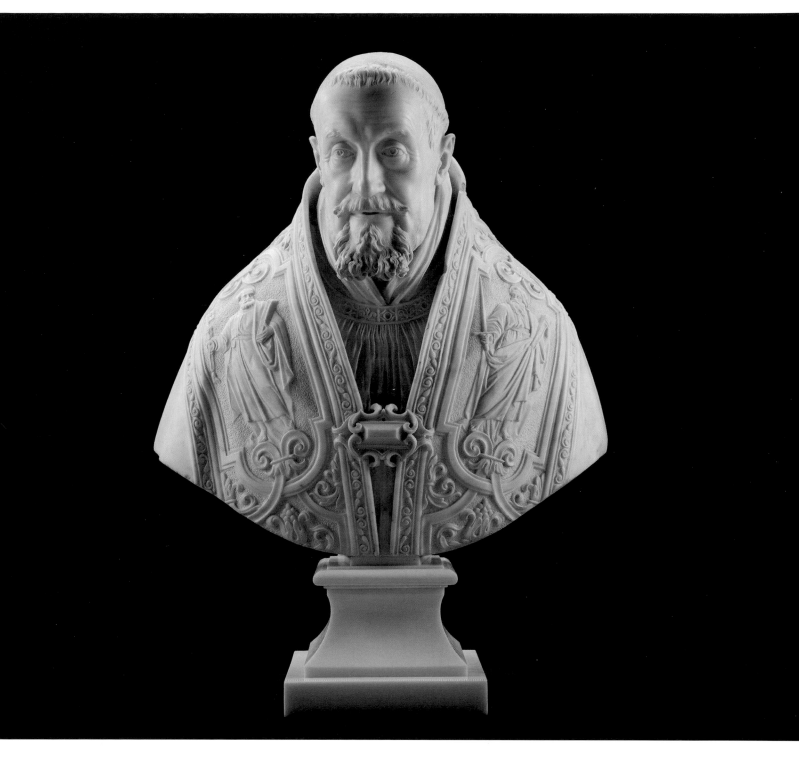

**Bibliography**

Avery, Charles. *Bernini: Genius of the Baroque*. Boston: Bulfinch, 1997.

Baldinucci, Filippo. *The Life of Bernini*. trans. and ed. C. Enggass. University Park: Pennsylvania State University Press, 1966.

Lavin, Irving. *Visible Spirit: The Art of Gianlorenzo Bernini*. 3 vols. London: Pindar Press, 2007–2011.

-----. "Five New Youthful Sculptures by Gianlorenzo Bernini and a Revised Chronology of His Early Works," *The Art Bulletin* vol. 50 n. 3 (September 1968): 223–248.

Teitelbaum, Matthew. "The Story behind the Bernini Acquisition," *Members' Journal* vol. 6 no. 4 (Summer 1998): 4–5.

Wittkower, Rudolf. *Gian Lorenzo Bernini: The Sculptor of the Roman Baroque*. Oxford: Phaidon, 1981.

# Gaspar de Crayer (Flemish, 1584–1669)

## Saint Benedict receiving Totila, King of the Ostrogoths

1633, oil on canvas, 274.5 x 544 cm
Gift of Joey and Toby Tanenbaum, 1995 (Inv. 95/140)

King Totila (r.541–552) led the Eastern Germanic tribe, the Ostrogoths, and defeated the Byzantine Empire in Italy during the Gothic Wars. He was particularly successful against Emperor Justinian during the battles at Verona and Faenza (541–542). Benedict, then an Abbot, received Totila at Monte Cassino, the first Benedictine monastery he established south of Rome. De Crayer focuses this monumental painting on the actual encounter when Totila kneels before Benedict who wears the characteristic black robe of his order. Totila's extensive retinue populates the rest of the canvas. De Crayer presents a diverse group of soldiers and attendants whose luminous armour, rich fabrics, and billowing pennants create visual interest across the large composition. Despite the scale of the work, de Crayer also develops a sense of intimacy by representing three sets of figures that turn to one another in conversation. The two men with their backs to the viewer in the centre of the work are particularly successful as the luxurious silk-lined red cloak and shadow cast by a sheath of the same figure's sword seem to extend into our space. To their left, an expectant Totila requests Benedict's blessing, which he was granted only after the Abbot chastized the king for his numerous cruel acts. Following this audience, Totila is said to have been more merciful towards the people he conquered, according to the *Dialogues* of Saint Gregory the Great. Saint Benedict of Nursia was canonized in 1220 and he is a patron saint of Europe.

Commissioned for the Refectory of the Benedictine Abbey of Saints Peter and Paul in Affligem, this work was likely removed from the monk's dining room and sold following the French campaigns of 1794 when the Southern (Austrian) Netherlands were invaded and annexed by the First French Republic and numerous Belgian Abbeys were destroyed. The works of fellow Flemish artists Peter Paul Rubens and Anthony Van Dyck were important models for de Crayer and he was a personal friend of both. De Crayer's work was inspired by *The Miracles of St. Benedict*, which Rubens was commissioned to paint for the same Abbey but was never completed due to his extensive diplomatic work in 1629–1630. *The Miracles of St. Benedict* may be the "painting of St. Benedict" that Hélène Fourment gave to de Crayer after Rubens' death in 1640 (Belgium, Musées Royaux des Beaux-Arts, n. 809). De Crayer was likely commissioned to execute *Saint Benedict receiving Totila, King of the Ostrogoths* to replace Rubens' work.

## Provenance

Painted for the Refectory of the Benedictine Abbey of SS. Peter and Paul, Affligem, 1633–c.1790
Ghent, J. de Cauwer, 1821
Jahbeke, Egide van Laerebeke, 2 August 1847, n. 2
Bois-le-Duc, M. van den Bogaerde, 19 June 1900, n. 48 (sold to Van der Does & F. Muller)
Heeswijk, Private Collection
Philadelphia, W.P. Wilstach (purchased 25 October 1900)
Philadelphia, Memorial Hall auction, 29 October 1954, n. 162 (likely sold to Reverend Collis)
Philadelphia, Church of St. Benedict
New York, Sotheby Parke Bernet, 9 January 1980, n. 81
London, Colnaghi, 1986
Private Collection
London, Christie's, 21 April 1989, n. 62
Toronto, Joey and Toby Tanenbaum, 1989–1995

## Exhibition History

Philadelphia, Fairmont Park, Memorial Hall, *The W.P. Wilstach Collection*, 1907, n. 72
London, Colnaghi, *Flemish Paintings and Sculpture*, Autumn 1986, n. 2
Toronto, Canadian Opera Company, 1990–1995

## Bibliography

Dom Bernard. *Geschiedenis der Benedictijner Abdij van Affligem*. Ghent: A. Siffer, 1890.
Gomicourt, Dérival de. *Le voyageur dans les Pays-Bas autrichiens, ou lettres sur l'état actuel de ce pays*. vol. 4 Amsterdam: Changuion, 1782–1783.
Maeteerlinck, Louis. "Gaspard de Crayer, sa vie et ses oeuvres à Gand," *Bulletin de la Société d'Histoire et d'Archéologie de Gand* vol. 8 (1900): 85–88.
Van Terlaan, E. "Un grand artiste méconnu: Gaspar de Crayer," *Gazette des Beaux-Arts* vol. 13 (1926): 93–108.
Vey, Horst. "Ein Wiedererkannter Gaspar de Crayer," *Pantheon* vol. 21 (July-August 1963): 243–246.
Vlieghe, Hans. *Gaspar de Crayer: Sa vie et ses oeuvres*. 2 vols. Brussels: Arcade, 1972.
-----. "Ongepubliceerde documenten over het werk van Gaspar de Crayer," *Gentse Bijdragen tot de Kunstgeschiedenis en Oudheidkunde* vol. 20 (1967–1968): 182–186.

**Gaspar de Crayer**
*Saint Benedict receiving*
*Totila, King of the Ostrogoths*

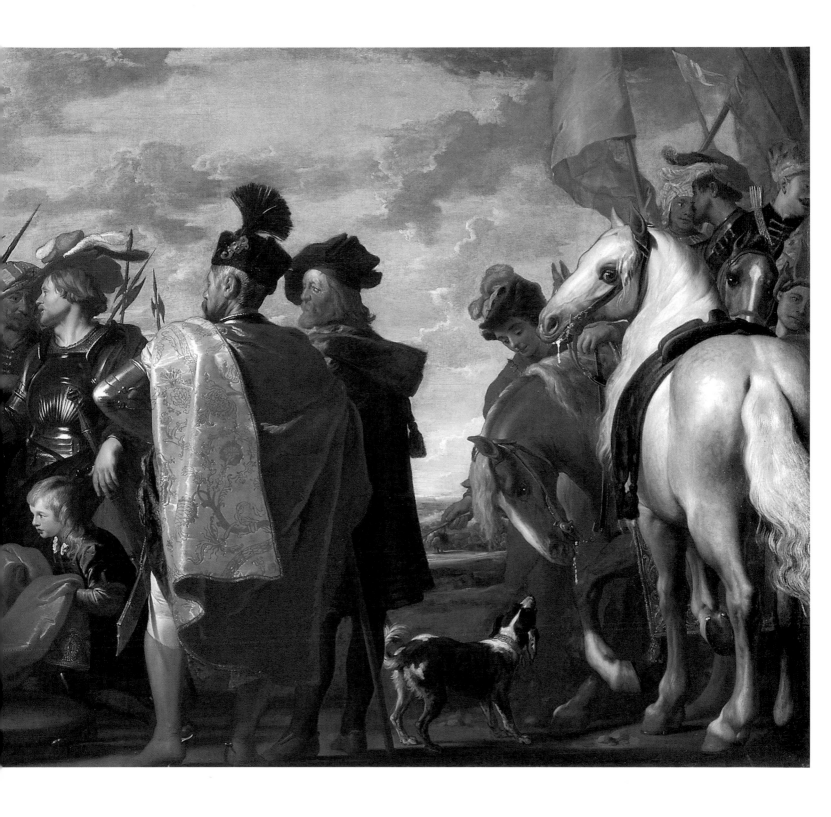

cat. 15
# Adriaen Pietersz. Van de Venne (Dutch, 1589–1662)
## *Dancing Peasants*

c. 1635, oil on wood, 45.1 x 68.3 cm
Gift of Dr. Anne Tanenbaum, 1989 (Inv. 89/114)

This lively scene of peasants dancing exemplifies Van de Venne's tonal representations of genre subjects after he moved to The Hague in 1625 and abandoned the more colourful palette of his earlier works. Van de Venne studied with Simon de Valck and Hieronymus van Diest, from whom he likely learned the *grisaille* technique we see in this painting. Strictly speaking, *grisaille* refers to monochromatic works that are predominantly grey in tone, but the term often encompasses works executed in *brunaille*, shades of brown with white heightening, as is the case here. This subtle approach to colour became Van de Venne's principal mode of pictorial expression from the time he became a member of The Hague's Guild of St. Luke in 1625, where he served two terms as deacon (1631–32, 1636–38), and went on to become dean in 1640.

During this period, Van de Venne took his subjects primarily from the lower social classes and he often emphasizes the moralizing nature of his representations with a banner containing a saying or pun. Works such as this, where an inscription is absent, are more difficult to decode so the scene remains somewhat enigmatic for the modern viewer. Van de Venne broadly executed the figures and landscape and likely intended the viewer to contrast the scene of peasant revelry in the center of the composition with the lone figure of a beggar who kneels with his hands in supplication in the right foreground. Both compositionally and metaphorically, this vagrant lives on the margins of society even in what appears, in general, as a low-life scene. On the left, the couple with a child also seem marginalized and serve as witnesses to the festivities. These contrasts may serve to symbolize worldly poverty and misery and could have illustrated a Dutch proverb. Certainly Van de Venne actively illustrated books and collaborated over several decades with Jacob Cats (1577–1660), the prominent poet and author of emblem books. *Dancing Peasants* evinces Van de Venne's strong connections with emblematic language and his close observation of human folly, which he approaches with humour. Van de Venne also published and illustrated his own literary works that are characterized by a similarly incisive response to contemporary life. Most significant among these are *Sinne-vonck op den Hollantschen turf* (Spark of sense on Dutch peat), *Wys-mal* (Wise folly) and *Tafereel van de belacchende werelt* (Picture of the ridiculous world), all published in 1634 and 1635, during the same years that Van de Venne likely painted *Dancing Peasants*.

## Provenance
New York, Schickman Gallery
Toronto, Mr. and Mrs. Max Tanenbaum, 1972–1983
Toronto, Dr. Anne Tanenbaum, 1983–1989

## Bibliography
Bol, Laurens J. *Adriaen Pietersz. van de Venne: Painter and Draughtsman.* Doornspijk: Davaco, 1989.

-----. 'Adriaen Pietersz. van de Venne, schilder en teyckenaer', *Tableau* vol. 5 (1982): 2–6; vol. 6 (1983): 1–5.

-----. "Een Middelburgse Brueghel-groep, viii. Adriaen Pietersz. van de Venne, schilder en teyckenaer," *Oud Holland* vol. 71–73 (1957–1958): 128–147.

Franken, Daniel. *Adriaen van de Venne.* Amsterdam: C. M. Van Gogh, 1878.

Franken, Daniel and F.G. Waller. "L'Oeuvre de Adriaen van de Venne," Unpublished manuscript, Amsterdam, Rijksmuseum, Rijksprentenkabinet, c. 1910.

Plokker, Annelies. *Adriaen Pietersz. van de Venne (1589–1662): De grisailles met spreukbanden.* Leuven: Acco, 1984.

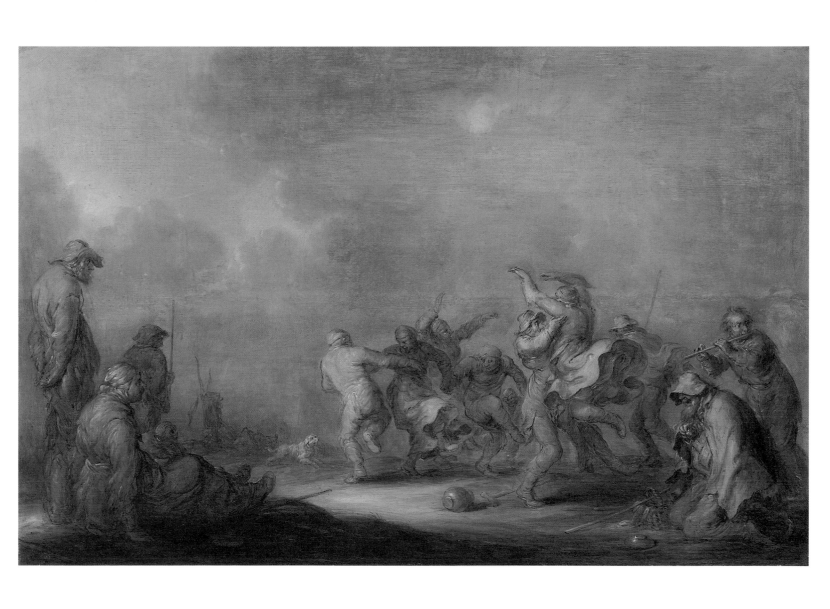

cat. 16

# Hendrick Andriessen (Dutch, 1607–1655)

## *Still Life (Vanitas)*

c. 1637, oil on panel, 49.3 x 64.2 cm
s.c. on document "…den Sci[l]d[er] D. Hendrick Andriessen dit bratteken heft ghemaeckt…"
Gift of Joey and Toby Tanenbaum, 1995 (Inv. 95/137)

These still life objects, which appear to be piled haphazardly on a table, contain a hidden allegory. A *vanitas* scene (Latin for emptiness) represents the transitory nature of earthly life and worldly possessions. The skull is crowned with laurel leaves, but victory is fleeting. The open timepiece, originally pinned with a blue ribbon, as well as the oil lamp and burning wick, suggest the passage of time. Worldly pleasures, such as reading, music making, and smoking, and indeed all of our pastimes and possessions disappear with death. Andriessen signed this work on the partially folded letter in the middle of the composition and thus may be acknowledging that he, and his artistic talents, will also pass from this earth. Ironically, though, Andriessen's letter also serves as a reminder that his payment for the work is due. Time is never too short to demand payment on a debt owed! The full inscription reads:

> This letter should be seen or read by the Council of the city of Antwerp, which has certified that the painter Hendrick Andriessen has produced this panel painting, for which he should have received, et cetera, and further to this document have we, the mayor and aldermen and the Council of Antwerp, not yet signed or sealed it.*

The letter is addressed to the Antwerp city council and the mark of the Guild of St. Luke is carved on the back of the panel, thus the work can be dated to 1637 or later when Andriessen became a member of the Antwerp Guild. Although painted in what was then the Spanish Netherlands, the iconography of this scene is closely connected with that found in Dutch still life paintings of the period. A painting such as this allowed Andriessen to display his wide array of talents. He presents a range of textures and the contrast of light and shadow, all within a tight composition. This work is among the six to nine signed paintings that have been attributed to Adriessen.

* Dese letteren sullen sien of lesen/De Raet der Stat van Anterpen/in sarticeerende dat den Sci[l]d[er]/D. Hendrick Andriessen dit/bratteken heft ghemaeckt ende/sijnen [loon ende]/daer op hij sal behoeren [te] hebben [ende]/te [ontvangen] et cetra ende meer-/der tot desen orconden hebben/wij borgumesteren scepenen […]/ende raet deser stat van/Antwerpen onse hant[teike]ns hier/toe niet ghesteld n[och] ghesegelt.

**Provenance**
Vienna, Private Collection
Vienna, Art Gallery, probably before 1914
Amsterdam, J. Goudstikker Gallery, 1932–1933
Amsterdam, Galerie P. de Boer, 1933
Amsterdam, Wilhelm Mautner collection, 1934
Amsterdam, Dr. J.A. van Dongen collection, 1948–1968
Amsterdam, Private Collection
Amsterdam, Douwes Brothers Fine Arts
Amsterdam, K. & V. Waterman Gallery, 1989
New York, Otto Nauman, 1995
Toronto, Joey and Toby Tanenbaum, 1995

**Exhibition History**
Rotterdam, Museum Boijmans van Beuningen, *Kersttentoonstelling*, 23 December 1932–17 January 1933, n. 1
Amsterdam, J. Goudstikker Gallery, *Het Stilleven*, 18 February–26 March 1933, n. 4
Dordrecht, Dordrechts Museum, *Nederlandse stillevens uit de zeventiende eeuw*, 21 July–21 September 1962, n. 2
Amsterdam, Museum Willet-Holthuysen, *Schilderijn, tekeningen en beeldhouwwerken 16e–20e eeuw uit de verzameling van Dr. J.A. Dongen*, 25 April–16 June 1968, n. 1
Tokyo, *Waterman Gallery Collection*, 1989, n. 55
Maastricht, *European Fine Arts Fair*, 1992
New York, Otto Naumann Ltd., *Inaugural Exhibition of Old Master Paintings*, 12 January–1 March 1995, n. 18
South Hadley, Mount Holyoke College Art Museum, *Hendrick Andriessen and the Vanitas Still Life: Reality and Metaphor*, 13 April–30 June 1996

**Bibliography**
Baadj, Nadia Sera. "Hendrick Andriessen's 'portrait' of King Charles I," *The Burlington Magazine* vol. 151 n. 1270 (January 2009): 22–27.
Bie, Cornelis de. *Het gulden cabinet van de edel vry schilderconst* ed. G. Lemmens Soest: Davaco 1971.
Greind, Edith. *Les peintres flamands de nature morte au XVIIe siècle.* Brussels: Elsevier, 1956.
Mautner, Wilhelm. "De schilder Hendrick Andriessen (Mancken Heyn) 1600?–1655," *Oud Holland* vol. 51 (1934): 260–266.
Vorenkamp, A.P.A. *Bijdrage tot de geschiedenis van het Hollandsch stilleven in de 17 eeuw.* Leiden: Leidsche Uitgeversmaatschappij, 1932.
Watson, Wendy M. *Hendrick Andriessen and the Vanitas Still Life: Reality and Metaphor.* South Hadley: Mount Holyoke College Art Museum, 1996.

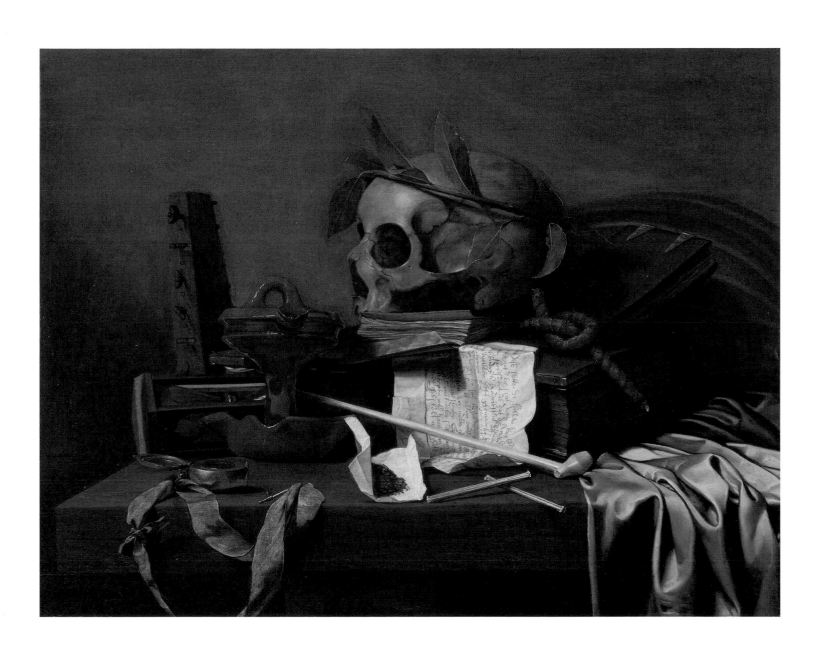

# Jan Victors (Dutch, 1619-after 1676)

## *The Levite and his Concubine at Gibeah*

1644, oil on canvas, 107.3 x 139.6 cm

s.d.l.l. Jan Victoors fc/1644

In memory of Mr. Max Tanenbaum, gift of Dr. Anne Tanenbaum, 1986 (Inv. 86/307)

This subject from the book of Judges is regarded as among the most disturbing of the *Tanakh*, the Hebrew Bible or Old Testament (19:15–21). The man and woman seated in the street are the Levite and his partner, a woman from Bethlehem, who is identified as a *pilegesh*, usually translated into English as concubine, but understood to mean wife or sexual partner. The woman may be referred to as a partner of secondary status because she became angry with her husband and metaphorically left him to return to her father's home. The couple was reunited and on their way back to the husband's country of Ephraim, north of Jerusalem, they stopped in the city of Gibeah for the night. Hospitality is very important in the ancient world and the couple was eventually offered accommodation by an old man who was also from Ephraim. The woman was then raped by the men of Gibeah and later died. Her husband cut her body into twelve parts and sent the pieces out to people in the neighbouring areas. Israelites then joined forces against the Benjaminites of Gibeah. This horrific story may be meant to illustrate the lawlessness that preceded the establishment of monarchic rule in Israel. Victors focuses on the most socially meaningful moment in the narrative when the couple are offered hospitality and thus saved from spending the night in the street. This subject resonated in the context of the Protestant Netherlands where the woman was believed to be an adulteress and the old man was regarded as a servant of God.

Characteristic of Victors, the couple are dressed in fine clothing and furs that are rendered in exquisite detail. The facial expressions and gestures are restrained but successfully convey the moment of an offer that is both acknowledged and received with some reservation, which we read in the woman's face and interpret as foreshadowing the events to come. Victors' artistic training remains undocumented but he is considered part of the school of Rembrandt in Amsterdam. *The Levite and his Concubine at Gibeah* dates to the middle years of Victor's career when he produced his most successful paintings. The subject was not common but does appear in Rembrandt's drawings and in the work of others in his circle. Victors adds interest to the composition with secondary figures such as the servant boy who tends to the donkey and the three figures in the background. In the latter grouping, an injured man seeks alms from a well-dressed man, an exchange that serves as a foil for the unsolicited offer of charity in the foreground. There is considerable difference in Victors' application of paint between the strong delineation of forms in the principal figures and the thin layers of paint that denote secondary areas such as the trees and atmosphere of the cloudy sky. However, recent restoration indicates this is due to past overcleaning of the background landscape. Victors later reworked the same subject, c. 1650, in a canvas now in the collection of the National Gallery of Ireland (NGI.879).

## Provenance

England, Collection of Sir Francis Davies

London, Sotheby's, 21 June 1950, n. 103 (sold to Bernard as *The Levite of Gibeah*)

London, Arthur Tooth & Son, 1950

London, Bonham (Smith Sale), 4 February 1965, n. 42

London, Ross-Lawson Gallery, 1967

The Hague, Hoogsteder Gallery

The Hague, G. Cramer Gallery

New York, Shickman Gallery

Toronto, Mr. and Mrs. Max Tanenbaum, 1972–1983

Toronto, Dr. Anne Tanenbaum, 1983–1986

## Exhibition History

London, Arthur Tooth & Son, 1950, n. 17

London, Matthiesen Fine Art Ltd., 1953, n. 64

The Hague, G. Cramer Gallery, 1968, n. 61

Montreal, Montreal Museum of Fine Arts, 9 January–23 February 1969; Toronto, Art Gallery of Ontario, 14 March–27 April 1969, *Rembrandt and his Pupils*, cat. 112

Sudbury, Laurentian University Museum and Art Centre, 6 May– 7 June 1992; Owen Sound, Tom Thomson Memorial Art Gallery, 30 October–29 November 1992; Kitchener/Waterloo Art Gallery, 18 December 1992–17 January 1993; Hamilton, McMaster Museum of Art, 7 February–7 March 1993; Peterborough, The Art Gallery of Peterborough, 25 March– 25 April 1993, *In the name of art, in the name of science*, cat. 8

## Bibliography

Manuth, Volker. "The Levite and his Concubine at the House of the Field Laborer in Gibeah: the iconography of an Old Testament Theme in Dutch Painting of Rembrandt's Circle," *Mercury* vol. 6 (1987): 11–24.

Miller, Debra. "Jan Victors (1619–76)," 2 vols. Ph.D. dissertation, University of Delaware, 1985.

Pigler, Andor. *Barockthemen: eine Auswahl von Verzeichnissen zur Ikonographie des 17. und 18. Jahrhunderts.* 2nd ed. Budapest : Akadémiai Kiadó, 1974.

Stechow, Wolfgang. "Some Observations on Rembrandt and Lastman," *Oud Holland* vol. 84 n. 2/3 (1969): 148–162.

Zafran, Eric. "Jan Victors and the Bible," *The Israel Museum News* vol. 12 (1977): 92–118.

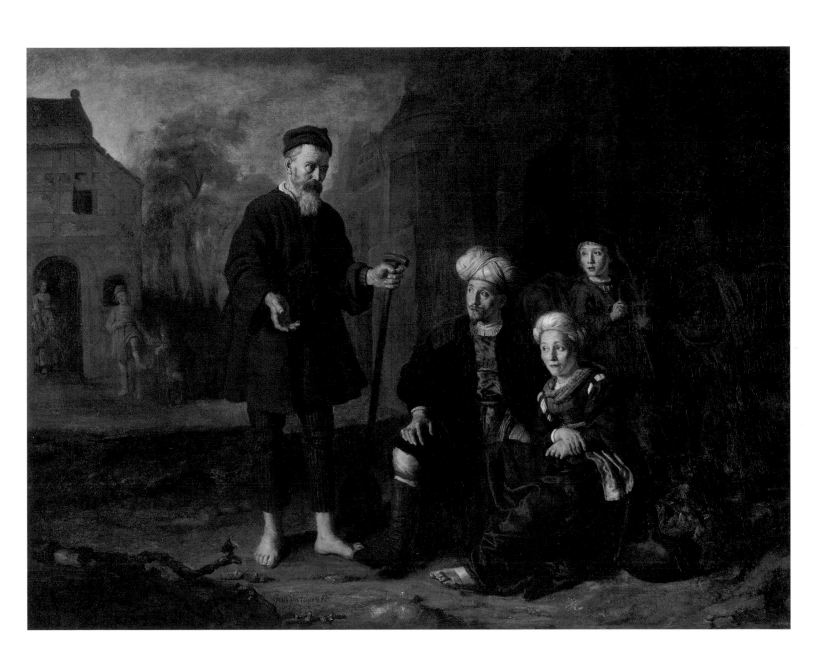

cat. 18
# Barent Fabritius (Dutch, 1624–1673)
## *Self-Portrait*

c. 1650, oil on canvas, 67.3 x 53.5 cm
Gift of Joey and Toby Tanenbaum, in memory of Mario Amaya, Chief Curator (1969–1972), 1986 (Inv. 86/237)

Fabritius' earliest works, such as *Self-Portrait*, exhibit the important influence of Rembrandt, however there is no documented evidence that he was ever Rembrandt's pupil. Fabritius studied with his father and Rembrandt's impact on his works may have occurred through Barent's elder brother Carel, who studied with Rembrandt from 1641 to 1643. Barent is documented as living in Amsterdam several times in the 1640s and 1650s and thus likely saw Rembrandt's work in the Dutch capital. While Barent's surviving oeuvre includes over forty works and is considerably larger than that of Carel, of the two Carel had a stronger posthumous reputation until Barent's work received attention in the 1860s from the French critic and art historian Théophile Thoré (William Bürger), who was responsible for reviving interest in several seventeenth-century Dutch artists including Vermeer and Hals.

Fabritius presents himself as a bust-length figure and illuminates his face dramatically before a dark background, all conventions Rembrandt practiced in his numerous portraits and self-portraits. The application of paint in this work is also closely connected with Rembrandt's techniques, particularly the contrast between the textured build-up of the surface in the areas of the face and collar and the more smooth application for the jacket, cap, and background. Although Fabritius largely produced history paintings and a few portraits, there is another self-portrait that he created around the same time in the collection of the Städelsches Kunstinstitut, Frankfurt. The *Self-Portrait* in the AGO evokes a generally peaceful and introspective mood while at the same time presenting Fabritius to us as a handsome and forthright young man.

**Provenance**

Florence, Count F. Celestini (attributed to Rembrandt)
Boston, Athenaeum, 1838–1979 (attributed first to Rembrandt school, then Fabritius)
New York, Sotheby Parke Bernet, 30 May 1979, n. 290
London, Norman Leitman
Toronto, Joey and Toby Tanenbaum, 1986

**Exhibition History**

New York, Clinton Hall, 1837
Boston, Museum of Fine Arts, 1876–1915, 1940–1969 (on long-term loan)
Chicago, Art Institute of Chicago, 23 October–7 December 1969; Minneapolis, Minneapolis Institute of Art, 22 December 1969–1 February 1970; Detroit, Detroit Institute of Art, 24 February–5 April 1970, *Rembrandt after Three Hundred Years: An Exhibition of Rembrandt and His Followers*, cat. 51
Boston, Museum of Fine Arts, 1970–1979 (on long-term loan)

**Bibliography**

Bürger, Willem. "Notes sur les Fabritius," *Gazette des Beaux-Arts* (1864): 100–104.
Cunningham, C.C. "Four Paintings of the Rembrandt School in Boston," *Art in America* vol. 17 (1939): 186–188.
Eckardt, Götz. *Selbstbildnisse niederländischer Maler des 17. Jahrhunderts*. Berlin, Henschelverlag, 1971.
Gilman, Margaret E. "An Early Self-Portrait by Barent Fabritius," *Bulletin of the Fogg Art Museum* vol. 10 n. 3 (March 1945): 80–86.
Hall, H. Van. *Portretten van Nederlandse beeldende kunstenaars*. Amsterdam: Swets & Zeitlinger, 1963.
Pont, Daniël. *Barent Fabritius: 1624–1673*. Utrecht: Haentjens Dekker & Gumbert, 1958.
Valentiner, W.R. "Carel and Barent Fabritius," *The Art Bulletin* vol. 14 n. 3 (September 1932): 197–241.

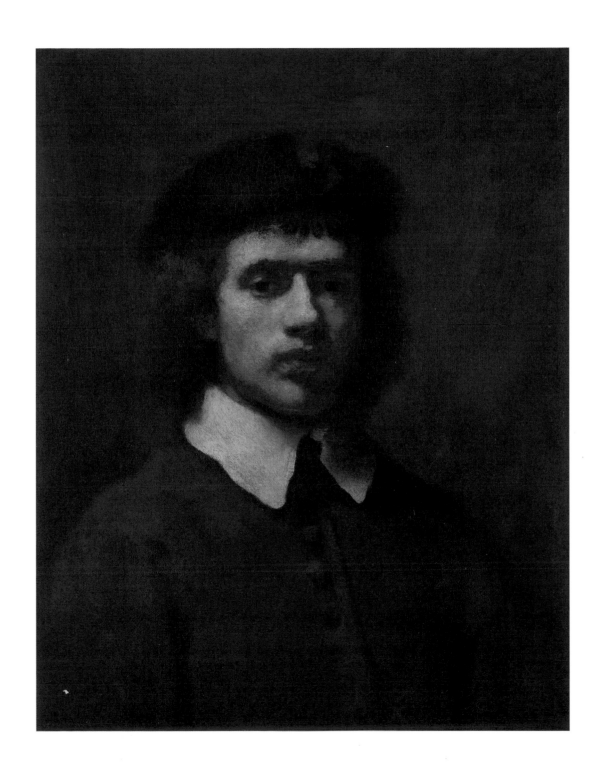

# Gaspar de Crayer (Flemish, 1584–1669)

## The Admission of Saint Bernard to the Cistercian Order
## A Cistercian Bishop with the Young Christ

c. 1660, oil on canvas, 260.8 x 157.8 cm; 260.5 x 172.1 cm
Gift of Joey and Toby Tanenbaum, 1995 (Inv. 95/141, 95/142)

The Order of Cistercians is a Catholic order of nuns and monks whose religious lives emphasize self-sufficiency and manual labour. They formed in France in the late eleventh century, separating from the Benedictines, with the goal of following the "Rule" written by Saint Benedict of Nursia (c. 480–547). This book of precepts offers spiritual and administrative instruction for autonomous communities. Cistercians are sometimes referred to as the White Monks due to the colour of their habit. These two large-scale paintings were almost certainly produced for a Cistercian context, although their early provenance remains unknown. De Crayer executed the monumental paintings around 1660 and his skillful handling of volume and local colour are integral to their success. Our attention is drawn to de Crayer's meticulous rendering of the jewel-encrusted Bishop's mitre and the reflective surfaces of the cross and staff. We are also attracted to de Crayer's humane representation of faces, particularly the tender exchange between the Bishop and a young Christ. The Cistercian desire to connect with Christ by emulating his life's path of humility and devotion are central to the moment de Crayer depicted in each work. In one, the Bishop experiences God's presence in physical form and in the other the bareheaded monk recognizes God's spirit blessing Bernard (1090–1153), a novitiate who became a principal reformer of the order. Saint Bernard of Clairvaux was canonized in 1174.

De Crayer studied with Raphaël Coxcie and established his career in Brussels, where he was appointed dean of the Guild of St. Luke from 1611 to 1616. He received many commissions from secular and religious institutions in Antwerp, Brussels, and Ghent (where he moved in 1664) and became court painter to two successive Austrian Governors of the Spanish Netherlands, Cardinal-Infante Ferdinand and Archduke Leopold William. De Crayer's work also attracted German and Spanish patrons. Altarpieces and religious works form the largest portion of de Crayer's oeuvre. He was well positioned in the context of the Counter-Reformation, which was established in the Southern Netherlands under Spanish power from 1579 to 1713. During this period there were many commissions to redecorate churches following the tenets of the Council of Trent. *The Admission of Saint Bernard to the Cistercian Order* and *A Cistercian Bishop with the Young Christ* can

be compared to a series of saints de Crayer painted for the Franciscan monastery in Burgos as well as his altarpieces for Église Saint-Martin in Ghent and Hôpital Saint-Jean in Bruges.

**Provenance**
Private Collection
London, Sotheby's, 7 December 1988, n. 126A & n. 126B
Toronto, Joey and Toby Tanenbaum, 1988–1995

**Bibliography**
Held, Julius S. "More on Gaspar de Crayer," *Master Drawings* vol. 27 n. 1 (Spring 1989): 53–63.

Vlieghe, Hans. *Gaspar de Crayer: Sa vie et ses oeuvres.* 2 vols. Brussels: Arcade, 1972.

-----. "Gaspar de Crayer: Addenda et corrigenda," *Gentsche bijdragen tot de kunstgeschiedenis* vol. 24 (1979–80): 159–207.

-----. "Drawings by Gaspar de Crayer from the Ghent Album," *Master Drawings* vol. 26 n. 2 (Summer 1988): 119–132, 170–189.

-----. "Further thoughts on the use of drawings in Gaspar de Crayer's Workshop," *Master Drawings* vol. 36 n. 1 (Spring 1998): 83–90.

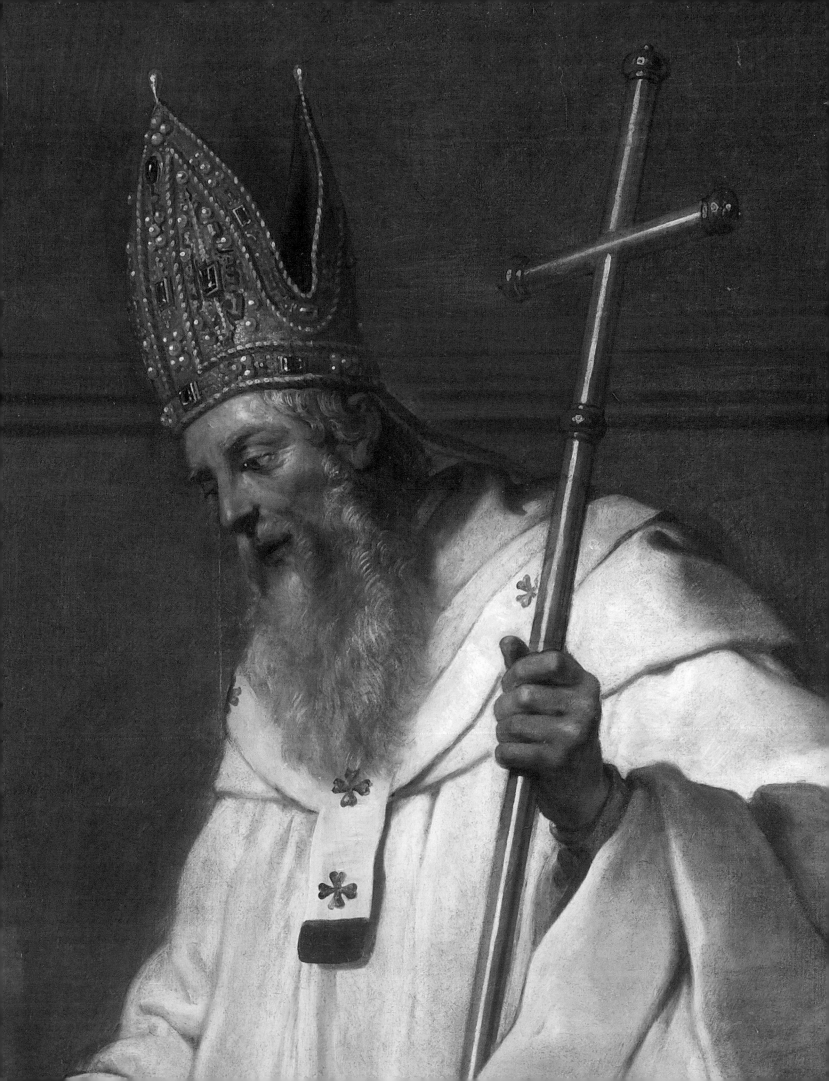

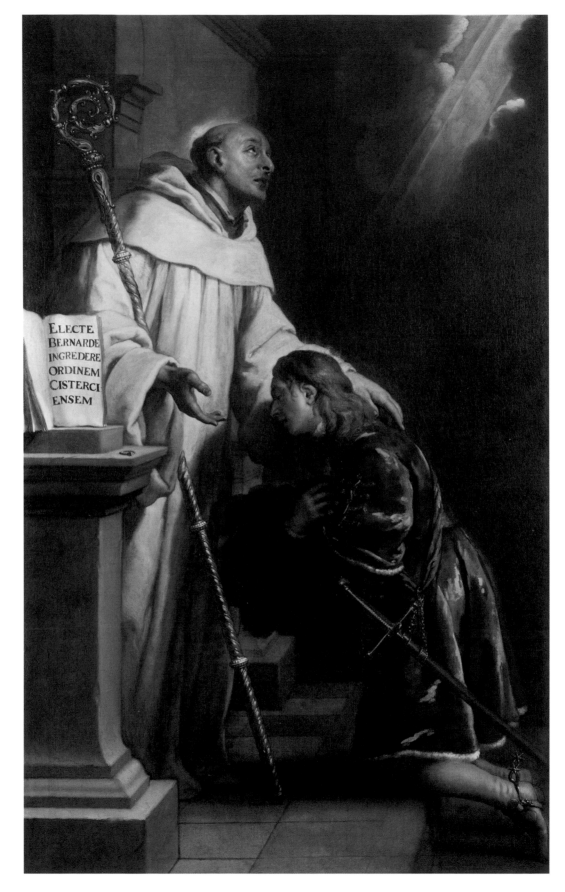

The text visible within the painting reads:

ELECTE
BERNARDE
INGREDERE
ORDINEM
CISTERCI
ENSEM

cat. 19

**Gaspar de Crayer** *The Admission of Saint Bernard to the Cistercian Order*

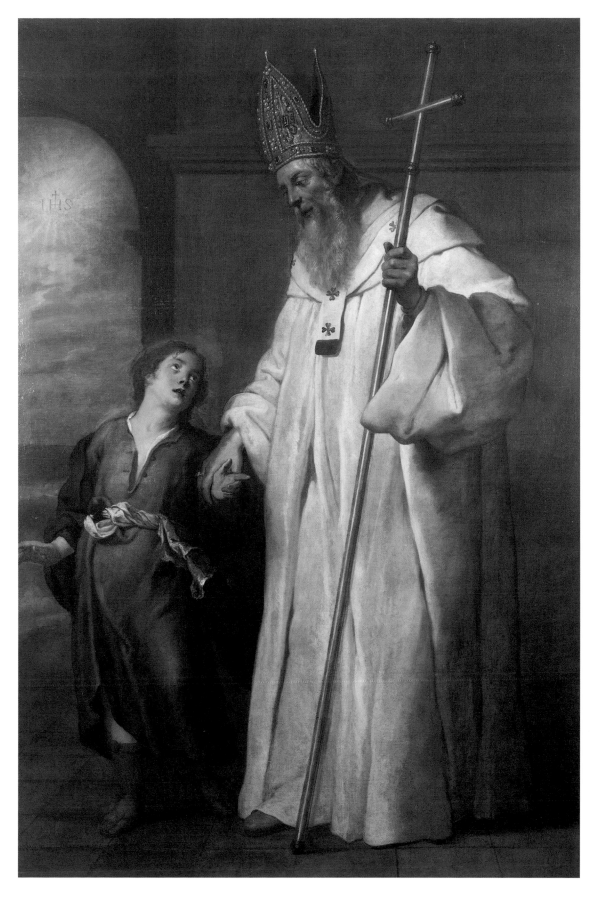

cat. 20

**Gaspar de Crayer** *A Cistercian Bishop with the Young Christ*

cat. 21, 22 & 23

# Luca Giordano (Italian, 1634–1705)

## The Toilet of Bathsheba

c. 1663, oil on canvas, 196 x 247 cm
Gift from the family of Mr. Max Tanenbaum in his memory, 1991 (Inv. 91/88)

## The Crucifixion of Saint Andrew

c. 1660, oil on canvas, 179.5 x 128.5 cm.
Gift of Joey and Toby Tanenbaum, 1995 (Inv. 95/144)

## Astronomy

c. 1653–1654 or 1680–1692?, oil on canvas, 127.4 x 99.5 cm
Gift of Joey and Toby Tanenbaum, 1995 (Inv. 95/145)

Giordano presents Bathsheba as a beautiful, full-figured woman, who is having her shoes removed as she prepares to bathe. David, King of Israel, catches sight of her and is smitten. (II Samuel 11:2–17). Although Bathsheba was married to Uriah, a general then fighting for the king, David had her brought to the palace, they made love, and she became pregnant. David then recalled Uriah, they feasted, and David made Uriah drunk but he abstained from going to bed with his wife. David then arranged for Uriah to be placed at the front of the battle lines, where he was killed. David and Bathsheba were then free to marry, although their first child only lived a few days. Giordano compresses his composition and focuses on one of the most preferred moments in this popular subject from the Renaissance and Baroque periods. David is out for a walk on the roof of his palace and spies Bathsheba at her bath. Many artists represented Bathsheba as unaware of the attention she attracts, or holding David's letter of invitation to the palace and resigned to her fate. In contrast, Giordano depicts Bathsheba looking directly at David, as a servant pulls back the drapery that was supposed to shield her privacy. An African servant is often included in Western European works of this period as a sign of the protagonist's status and to add an element of exoticism to the scene. In Giordano's work, the role of this servant also draws on associations of African women and hyper sexuality, a stereotype that is exploited and perpetuated by many Caucasian artists through the nineteenth century. Above the drapery and in the center of the composition, a goldfinch flies towards Bathsheba. The goldfinch is often included in Italian art as a symbol of Christ's Passion and in this painting it functions typologically, connecting David to Christ.

Giordano uses the Baroque device of dramatic diagonals in many of his compositions. In The Toilet of Bathsheba, implied lines intersect between Bathsheba and the African servant, and lead the viewer's eye up to the figure of David.

In The Crucifixion of Saint Andrew, Giordano positions the viewer directly before the saint whose muscular body is at the center of a composition of strong diagonals created by his outstretched arms and a suggestion of his legs. Andrew was a fisherman from Galilee, along with his brother Peter, and was among the first to become an apostle of Christ. Details of his life are recounted in the apocryphal Acts of Andrew from the 3rd century, as well as the Golden Legend. As a missionary he made several journeys to Russia, Asia Minor, and Greece but was condemned to death by Egeas, a Roman governor in the Peloponnese, whose wife had converted to Christianity and had agreed to follow Andrew's advice and renounce further sexual relations with her husband. Egeas had Andrew imprisoned and crucified on a saltire, a cross with diagonal bars of equal length. In Giordano's painting, Egeas is likely the figure on horseback that raises his hand in an authoritative gesture. Accounts detail that Andrew was tied to the cross with rope and Giordano also includes a subtle halo of light around his head and a putto, who carries a palm branch to signal Andrew's status as a martyr for his faith. The helmeted man in the foreground is among those who raise up Andrew's cross, which when erect Giordano implies would be pushed out in the viewer's space. As spectators before this work, we are further implicated in the events represented by the dog to the right of Andrew's exposed knee, who looks directly out and meets our gaze. The immediacy of this dramatic scene is central to its success as a work of the Counter-Reformation period in Italy where the church sought to use art to consolidate aspects of faith and connect more closely with worshippers.

In that same context, scientific discoveries such as those in the field of astronomy were a significant threat to religious authority and that likely informs the soul-searching and circumspect gaze of the solitary figure in Giordano's Astronomy. This half-length portrait-like representation

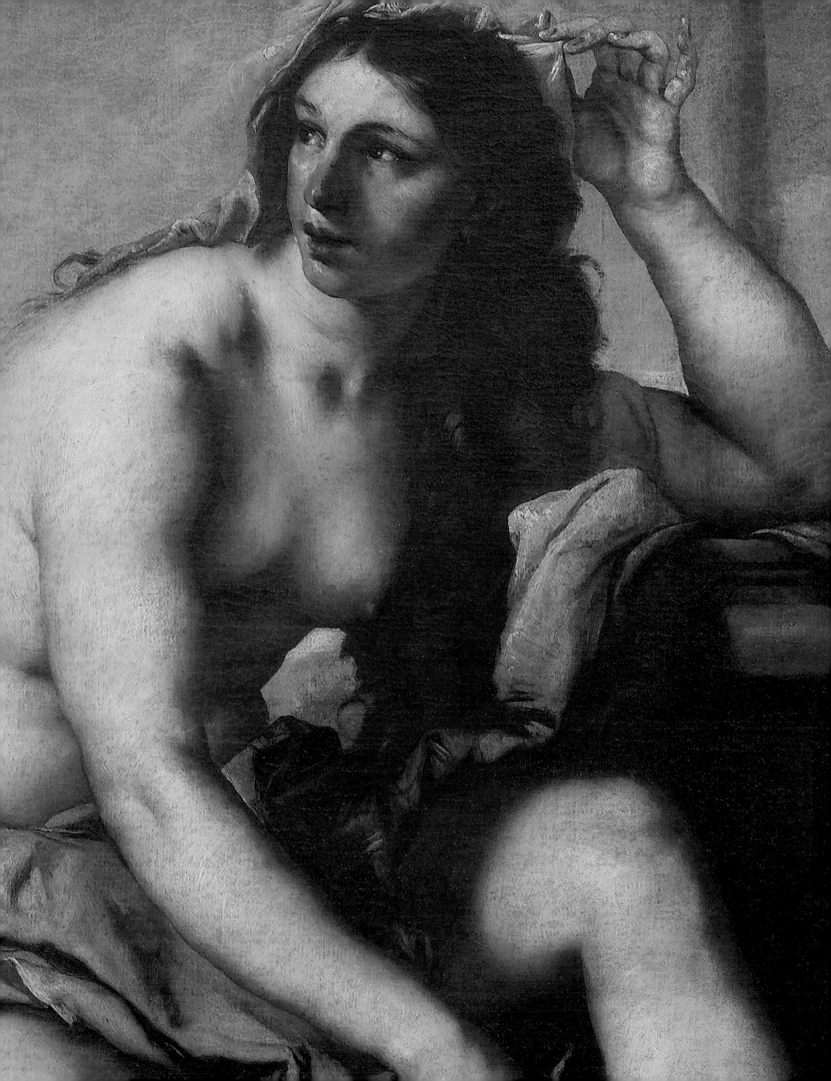

of a shabbily dressed man before a blank backdrop is part of a strong tradition that demonstrates Giordano's close ties to Spanish artist Ribera. Ribera was active in several Italian cities throughout his career, including Giordano's native Naples where he was commissioned to paint a series of ancient philosophers in 1636 (formerly Prince of Liechtenstein collection). The striking realism of Giordano's *Astronomy* has a close connection to these and other related works by Ribera. Giordano himself painted several images of philosophers, which are variously dated to the 1650s and 1660s. *Astronomy* also exemplifies tenebrism, the 17th-century style of painting characterized by dark shadows and strategic areas of light manifest in the work of both Caravaggio and Ribera. The field of astronomy developed significantly in the sixteenth and seventeenth centuries through the research of Copernicus (1473–1543) and Galileo (1564–1642). Copernicus' heliocentric theory was published in 1543 when he challenged the theory of the earth as the center of the universe, a view which prevailed in Europe since Ptolemy in the 2nd century. Galileo's refinements of the telescope in 1609 and his astronomical observations supported Copernicanism, but his research remained controversial and was regarded as heresy. It is within this context of intellectual and spiritual debate that we must place Giordano's dramatically expressive *Astronomy*. The astronomer appears to be writing down his ideas as he holds a globe close to his body, and a large star with a subtle line extending like a tail features prominently on the side of the globe that faces the viewer. Galileo published his *Discourse on the Comets* in 1619. After Galileo's death, Isaac Newton (1642–1727) became increasingly interested in the subject following the Great Comet of 1680. In his *Principia Mathematica* published in 1687, Newton demonstrated how the path of the comet of 1680 was in the shape of a parabola, which could be what appears on Giordano's globe as the arching line through the right third of the star. Given this context, Giordano may have produced *Astronomy* after 1680 and during the last decades of his prolific career.

Giordano was an internationally acclaimed Baroque artist who travelled extensively and worked in Venice, Florence, and Madrid as well as Naples. He was the son of painter Antonio Giordano and may have trained with Ribera, or someone in his circle. Certainly the Spanish artist had a profound impact on his work. Giordano received numerous commissions for his easel paintings and later in his career was also commissioned for fresco cycles at the churches of Santa Brigida and San Gregorio Armenio among others in Naples as well as for the library and gallery of the Palazzo Medici-Riccardi in Florence. In 1692, Giordano left Italy for Spain where King Charles II appointed him court painter in 1694. In Spain, Giordano worked extensively at the Escorial, the Buen Retiro in Madrid, the Cathedral in Toledo, and elsewhere until he returned to Naples in 1702 where he remained active until his death. Giordano enjoyed widespread fame during his lifetime and attracted many students.

**Provenance** (*The Toilet of Bathsheba*)
London, Heim Gallery, 1966–1972
Toronto, Mr. and Mrs. Max Tanenbaum, 1972–1983
Toronto, Dr. Anne Tanenbaum, 1983–1991

**Exhibition History** (*The Toilet of Bathsheba*)
London, Heim Gallery, *Italian Paintings and Sculpture of the 17th and 18th centuries, Summer Exhibition*, 1966, n. 14 (attributed to Antonio Zanchi)
London, Heim Gallery, *Fourteen Important Neapolitan Paintings*, 13 May–28 August 1971, n. 7 (attributed to Giordano)
Toronto, Art Gallery of Ontario, 1972–1991 (on long-term loan)

**Provenance** (*The Crucifixion of Saint Andrew*)
Private Collection
Rome, Christie's, 11 May 1993, n. 104 (bought in)
Rome, Christie's, 1 June 1994, n. 395
Toronto, Joey and Toby Tanenbaum, 1994–1995

**Provenance** (*Astronomy*)
Monaco, Sotheby's, 16 June 1989, n. 311 (bought in)
Toronto, Joey and Toby Tanenbaum, 1989–1995

**Bibliography**
Ferrari, Oreste and Giuseppe Scavizzi. *Luca Giordano*. Naples: Edizioni scientifiche italiane, 1966.
Ferrari, Oreste, Giuseppe Scavizzi and Daniela Campanelli. *Luca Giordano l'opera completa*. Naples: Electa, 1992.
Ferrari, Oreste, Wilfried Seipel et al. *Luca Giordano, 1634–1705*. Naples: Electa, 2001.
Vitzthum, Walter. *Luca Giordano*. Milan: Fratelli Fabbri, 1966.

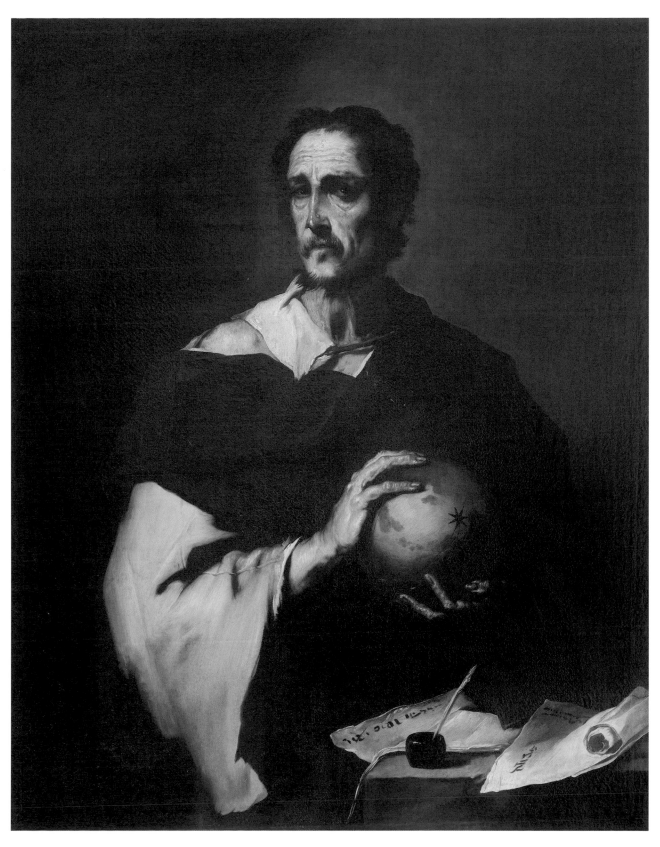

cat. 23
**Luca Giordano** *Astronomy*

**Luca Giordano**
*The Toilet of Bathsheba*

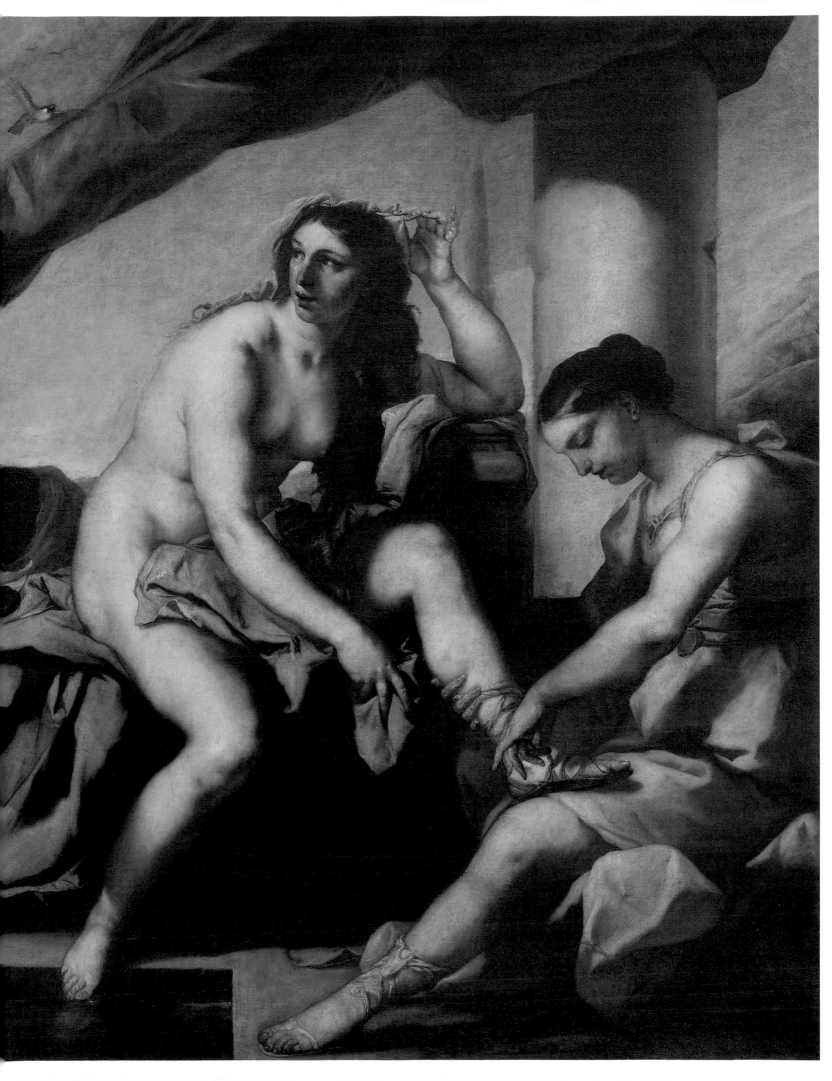

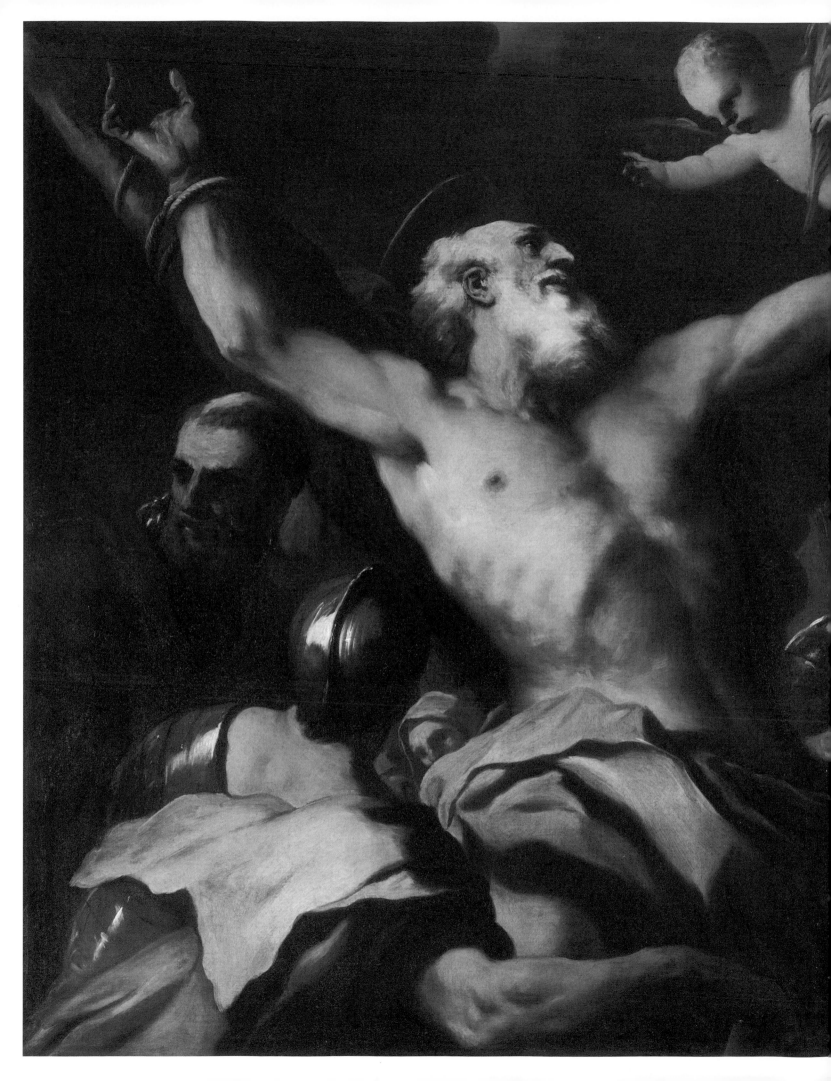

**Luca Giordano**
*The Crucifixion of Saint Andrew*

cat. 24

# Giuseppe Simonelli (Italian, 1649/1650–1710)

## *The Battle between the Israelites and the Amalekites*

1689–1690, oil on canvas, 152.5 x 210.5 cm
Gift of Joey and Toby Tanenbaum, 1995 (Inv. 95/143)

Muscular soldiers brandish their weapons and horses collide in this densely concentrated composition. The scene represents the intense conflict that developed when Moses led the Israelites out of Egypt and they stopped at Rephidim where they could not find drinking water (Exodus 17). Moses followed God's orders, and struck a rock in Horeb, from which water flowed and nourished his followers. The Amalekites then attacked them and Joshua led the Israelites in battle. He is likely the figure on horseback carrying the blue banner that distinguishes him from the other soldiers. The crowd of figures in the middleground of the painting, set before the rocky landscape, conveys the magnitude of the battle while the stormy sky emphasizes the violence of the event. In the upper left-hand corner, Moses bears witness to the scene and is bathed in mystical rays of light that emanate from God. In fact, Moses noticed that when he raised his arm the Israelites advanced while if he lowered it the Amalekites prevailed. Moses thus spent the day with his weary arms supported by Aaron and Hur. After their triumph over the Amalekites, Moses led the Israelites to the Sinai Peninsula.

Simonelli was a pupil of the leading Neapolitan artist Luca Giordano, to whom this painting was previously attributed. Recent scholarship on the work of Giordano's pupils enables us to connect this painting with a related compositional drawing that survives in two separate pieces. *The Battle between the Israelites and the Amalekites* is likely a pendant for another painting, *Joshua Halting the Sun*, which is in a private collection in Milan. Simonelli may have developed both compositions following lost works by Giordano, or he collaborated on these paintings with his teacher and then translated the battle scene into his own drawing. Giordano had a large workshop and, according to some accounts, as many as thirty assistants. Simonelli worked closely with his teacher, often following his ideas laid out in spontaneous oil sketches, known as *bozzetti*. Simonelli also completed several works that were begun by his teacher but left unfinished at the time of Giordano's death, including important paintings in the churches of Saint Brigida and Donnaregina Nuova, in Naples.

**Provenance**

Private Collection
London, Christie's, 21 April 1989, n. 86 (attributed to
   Luca Giordano)
Toronto, Joey and Toby Tanenbaum, 1989–1995

**Bibliography**

Ferrari, Oreste and Giuseppe Scavizzi. *Luca Giordano: nuove
   ricerche e inediti.* Naples: Electa, 2003.
-----. *Luca Giordano: l'opera completa.* Naples: Electa, 1992.
Scavizzi, Giuseppe. "Drawings by artists in Giordano's Circle:
   Simonelli, Malinconico, and De Matteis," *Master Drawings*
   vol. 37 n. 3 (Autumn 1999): 238–261.

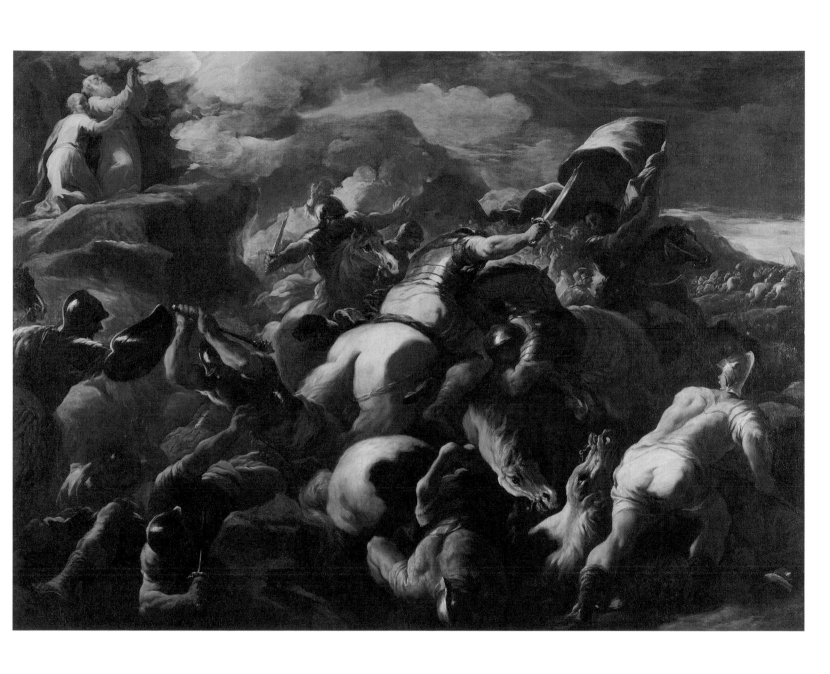

# Antoine Coypel (French, 1661–1722)

## *The Death of Christ on the Cross*

1692, oil on canvas, 111 x 168 cm
Gift of Joey and Toby Tanenbaum, 1995 (Inv. 95/139)

Commissioned by Louis François Armand de Vignerot Du Plessis, duc de Richelieu (1629-1715), Coypel's *The Death of Christ on the Cross* was praised by those who saw it in the duke's collection in Paris as early as 1692. Coypel created a dynamic composition from the traditional subject of Christ crucified between two robbers focusing on the exact moment of Christ's death when witnesses suddenly recognized him as the son of God (Matthew 27: 45–54). Typical for a work of the Baroque period, light enters the composition from an unknown source, here identified as heavenly rays that illuminate Christ's body and the specific figures grouped below: the Virgin Mary who wears blue and stands to Christ's left, Mary Magdalene who crouches at his feet, and one of the saints raised from death on the far right of the composition. The figure of the sponge-bearer on horseback is significant. Although unnamed in the Gospels, this Roman soldier was later called Stephaton and he symbolized the Synagogue. His extended arms, direct scrutiny of Christ's face, and open mouth all signify this as the moment when Stephaton realizes he took mercy on the man who is indeed the son of God. In a preparatory drawing for the full composition, now in the collection of the J. Paul Getty Museum (88.GB.41), it was another Roman soldier, Longinus, who has his back to the viewer having just removed the lance he used to pierce Christ's side. Coypel's changes strengthened the impact of the final composition and the viewer's sense of connection with the events. The central section of the work is bound by two lines: the rod bearing Stephaton's sponge and the ladder being readied to remove Christ from the cross. The extension of these implied lines intersect at the ground closest to the viewer, where we find an allusion to the Fall: a snake and two skulls, one of which is traditionally identified as the skull of Adam. The strong emotive colour and dynamic composition have often been noted as Rubensian qualities in Coypel's *The Death of Christ on the Cross*.

Antoine Coypel was trained first in the studio of his father Noël Coypel and furthered his studies during the years his father was director of the French Academy in Rome (1672–1675). In Italy, he was inspired both by the works of contemporaries Gianlorenzo Bernini and Carlo Maratta, as well as antique art and the work of Raphael, Michelangelo, Domenichino, and the Carracci. He became a member of the French Academy in October 1681 and his *morceau de réception* (reception piece) was *Louis XIV Resting in the Lap of Glory after the Peace of Nijmegen* (Montpellier, Musée Fabre). Coypel became a professor of the Academy in 1707 and was made director in 1714. He was appointed First Painter to the king the following year and in this capacity painted the ceiling of the Royal Chapel at Versailles (1716). *The Death of Christ on the Cross* was among the most admired of Coypel's works during his lifetime. The duc de Richelieu was a celebrated collector of works by Peter Paul Rubens and Coypel often frequented his collection, where he made a copy after Rubens's *Lion Hunt*.

### Provenance

Paris, Duc de Richelieu, 1692–1704 or later
Lyon, Mme Balaÿ
Bourg-en-Bresse, Hôtel des Ventes (Me. M.A. Kohn), 12 April 1987, n. 121 (as anonymous)
Aix en Provence, Art market
Lyon, Frédéric Lajoie
Monaco, Sotheby's, 6 December 1987, n. 66
Toronto, Joey and Toby Tanenbaum, 1987–1995

### Exhibition History

Paris, Salon de 1699, p.13
Paris, Salon de 1704, p.13
Toronto, Art Gallery of Ontario, on long term loan 1988–1990

### Bibliography

Bailey, Colin B. *Les amours des dieux: la peinture mythologique de Watteau à David*. Paris: RMN, 1991.

Coypel, Charles-Antoine. "Vie d'Antoine Coypel," in Bernard Lepicié *Vie des premiers peintres du Roi depuis M. Le Brun jusqu'à présent*. vol. 2 Paris: Durand, 1752, 8–9.

"La première exposition de peinture au Louvre en 1699," *Le Magazin pittoresque* vol. 18 (1850): 306.

Le Comte, Florence. *Cabinet des singularitez d'architecture, peinture, sculpture et graveure*. vol. 3 Paris: Nicolas Le Clerc, 1700.

Garnier, Nicole. *Antoine Coypel (1661–1722)*. Paris: Arthena, 1989.

*Mercure galant* (December 1692): 289–298.

Mérot, Alain. *La peinture française au XVIIe siècle*. Paris: Gallimard, 1994.

Ramade, Patrick et al. *Century of Splendour: Seventeenth-Century French Painting in French Public Collections*. Montreal: Museum of Fine Arts, 1993.

Schnapper, Antoine. "The Moses of Antoine Coypel," *Allen Memorial Art Museum Bulletin* vol. 37 (1979–1980), 61–62 (as lost).

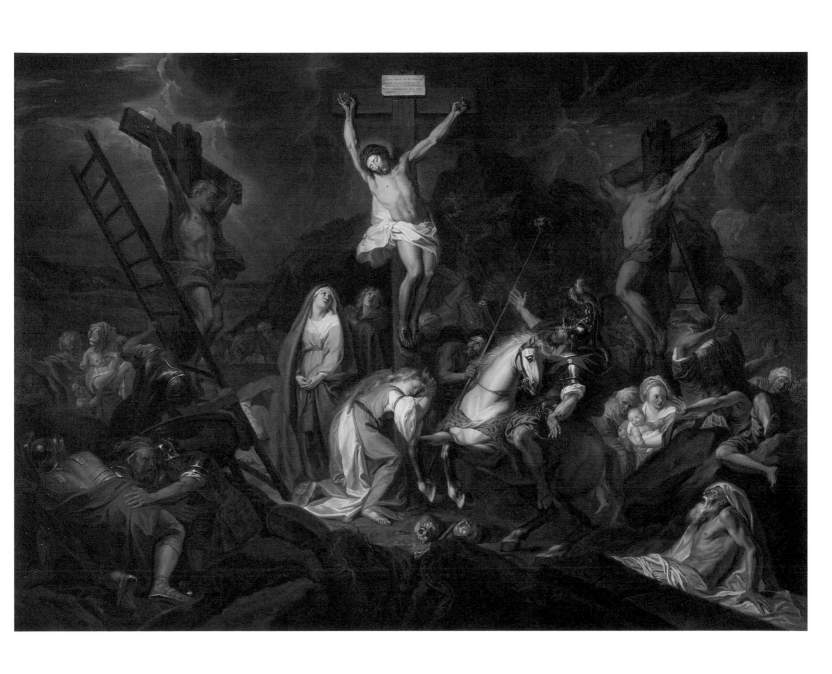

# Esteban Márquez de Velasco (Spanish, c. 1655–1720)

## *The Dormition of the Virgin*

1690s, oil on canvas, 252.2 x 160 cm
Gift of Joey and Toby Tanenbaum, 1995 (Inv. 95/148)

Scenes of the death of the Virgin Mary form a cycle that has been popular in Christian Art, particularly for churches dedicated to Christ's mother. Information on the Virgin's death comes from apocryphal sources, the earliest dating to the 4th century. The most extensive account is in Jacobus de Voragine's *Golden Legend* from the 13th century. The details of Márquez de Velasco's work suggest it is based on the *Golden Legend*: the Virgin is surrounded by the apostles, who have gathered from all over the world, while Christ and the heavenly angels await the ascent of her soul. The Virgin's gesture and her upward gaze suggest this is the very moment when her soul was released from her physical body and conveyed to Christ's expectant arms. One tradition indicates that during the three days prior to this event the Virgin was not dead but sleeping, and dormition means a peaceful and painless death (from Latin dormire: to sleep). St. John the Evangelist kneels at the foot of the bed; St. Peter holds a book and leads the service. The apostles manifest a range of emotional responses and the various figural groupings are connected through tender and sentimental expressions as well as tonal harmonies, particularly the repetition of violet hues in the drapery and clothing.

Márquez de Velasco was commissioned to paint *The Dormition of the Virgin* as part of a series of eight scenes from the Life of the Virgin for the Convent of La Trinidad Calzada in Seville, where the work hung until the French occupation of Spain from 1808 to 1814. During these years of the Peninsular war, Napoléon Bonaparte issued laws to abolish religious orders and soldiers expropriated the property of Spanish churches. It is estimated that over 1,200 works were removed from monastic buildings and gathered at the Alcázar, the Royal Palace in Seville, from which they were dispersed by French generals. All eight paintings from the series at La Trinidad Calzada were sold individually at auction in London in 1810, where they were identified as works by Murillo that originated from Seville. Subsequently, *The Dormition of the Virgin* has been in numerous international collections, and even returned to Spain where it was in a private collection in Barcelona in the late 1920s. Scholars have since identified *The Dormition of the Virgin* as a work by Márquez de Velasco for several decades. He trained with his uncle Fernando Márquez and was among the numerous Sevillan artists who were inspired by Murillo. The North

Carolina Museum of Art holds another painting from the same cycle, *The Marriage of the Virgin* (52.9.180), and dates the work to c. 1693. *The Dormition of the Virgin* likely dates to the 1690s when Márquez de Velasco also completed works for the Colegio de San Telmo in Seville and Santa Maria de las Nieves in Fuentes de Andalucía.

## Provenance

Seville, Convent of La Trinidad Calzada
London, Lionel Harris
London, Christie's, 16 June 1810, n. 5 (as Murillo, sold to Lee)
Cochrane Johnson
Manning, c. 1820
Lord Biddulph
London, Christie's, 19 May 1916, n. 105 (as Murillo, sold to Nicolson)
Barcelona, Adolphe Marx, 1928
Private Collection
London, Christie's, 23 April 1993, n. 43
Toronto, Joey and Toby Tanenbaum, 1993–1995

## Exhibition History

Seville, *Exposición Ibero-Americana*, October 1928, p. 29

## Bibliography

Angulo Iñiguez, Diego. "Varias obras de Esteban Márquez attribudas a Murillo," *Goya* n. 169–171 (July-December 1982): 3–6.
Curtis, Charles Boyd. *Velasquez and Murillo*. London: Low, Marston, Searle & Rivington, 1883.
Ponz, Antonio. *Viage de España, IX*. 2nd ed. Madrid: Ibarra, 1786.
Valdivieso, Enrique. *Historia de la pintura sevillana: siglos XIII al XX*. Seville: Ediciónes Guadalquivir, 1986.

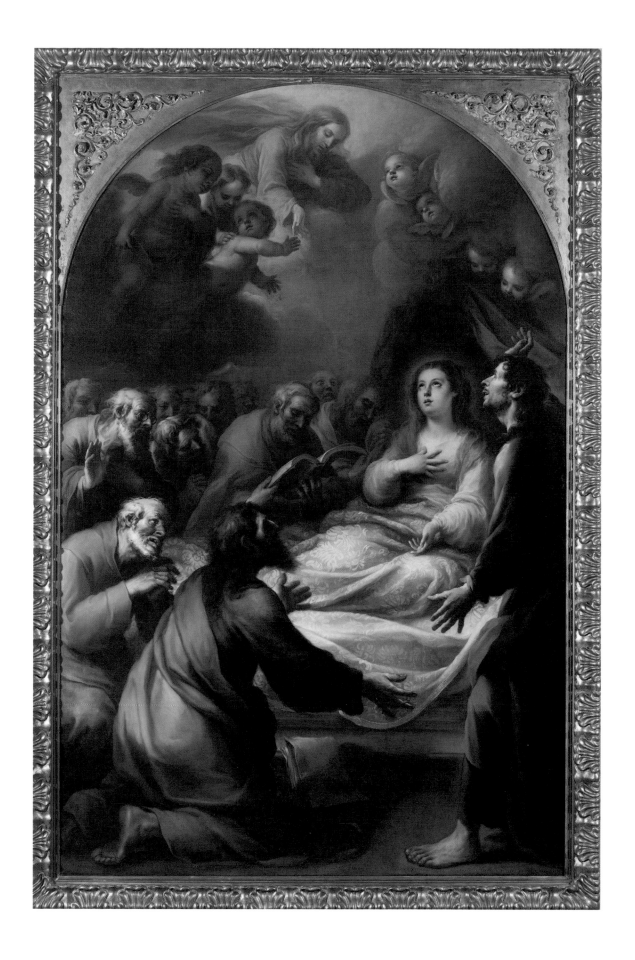

cat. 27

# Jean-Baptiste Jouvenet (French, 1649–1717)
## *The Lamentation*

c. 1704, oil on canvas, 130.5 x 81.5 cm
Gift of Joey and Toby Tanenbaum, 1995 (Inv. 95/147)

The term "Lamentation" describes the scene immediately after the *Deposition* or *Descent from the Cross*. Christ's body has been placed on the ground, or on an altar-like block of stone, and he is surrounded by mourners. The subject is not mentioned in the Gospels but appears in Byzantine art in the 12th century and in Western European art by the 13th century. Jouvenet goes beyond the usual representation of the Virgin Mary, St. John the Evangelist, and Mary Magdalene and includes four additional figures who manifest different responses to the event. Joseph of Arimathea holds the cloth that forms a dramatic swath of drapery behind Christ's head. He is accompanied by Nicodemus at Christ's feet. The two male figures at the base of the ladder show no emotional connection; they have been engaged in removing Christ's body from the cross and remain focused on their task. On the far right, Mary Magdalene's head and face are entirely shrouded and she is consumed by grief, as is the young St. John the Baptist below her. By contrast, the Virgin Mary embodies strength and equanimity: her direct gaze to heaven and the gesture of her open arms signify that Christ's body is offered now unto God. Jouvenet arranged the figures in a tight configuration that almost fills the full width of the canvas. The strong verticality of the work opens to the sky and suggests the cross looming above the figures. In the foreground, the shallow dish used to cleanse Christ's wounds is filled with a mixture of blood and water that represents the Eucharist. Along with the large stones, these symbolic still-life objects positioned closest to the viewer serve as *repoussoir* elements, objects that metaphorically lead one into the composition.

Born in Rouen, Jean-Baptiste Jouvenet received his first training from his father Laurent; he may also have studied with Poussin. Jouvenet became a member of the *Académie royale de peinture et de sculpture* in 1675, was elected a professor in 1681, and was director of the academy from 1705 to 1708. In 1707 he was made one of the four perpetual rectors of the academy, a significant honour as rectors were nominated by the king. Jouvenet was considered the most influential religious painter of his generation and he exhibited his principal version of this work at the Salon of 1704 (whereabouts unknown). He painted another version with an arched top in 1708 which was given to the Jesuit order in Pontoise northwest of Paris; it remains in that city in the

Église Saint-Maclou. Jouvenet executed a number of autograph repetitions that are in the Chapelle des Élus at the Palais des États, Dijon (signed and dated 171[3]), and the Musée des Augustins, Toulouse (signed and dated 1714; formerly in the Église de Beaumont-de-Lomagne). Other studio replicas are also doccumented in the authoritative scholarship of Antoine Schnapper. The reduced format and minor differences in composition suggest that the work from the Tanenbaum collection may well have been produced in preparation for the large scale painting. This work is neither signed nor dated and the fresh and vigorous nature of the brushwork suggests it was not a studio copy.

### Provenance
Châtres (Seine-et-Marne), Grande-Mesnil, Mme Madeline (née Hallé), by descent from the artist, 1974
New York, Colnaghi, 1985–1991
Monaco, Sotheby's, 5 December 1992, n. 17
Toronto, Joey and Toby Tanenbaum, 1992–1995

### Exhibition History
New York, Colnaghi, 31 October–7 December 1991, *European Paintings 1550–1800*, n. 19

### Bibliography
Leroy, François-Noël. *Histoire de Jouvenet*. Paris: Didron, 1860.
*Liste des tableaux et des ouvrages de sculpture, exposez dans la Grande Gallerie du Louvre, par Messieurs les Peintres, & Sculpteurs de l'Académie Royale, en la presente année 1704* [Salon de 1704]. Paris: Louvre, Grande Galerie, 1704.
Loche, Renée. "Le thème de la déposition de croix dans l'oeuvre de Jean Jouvenet: à propos d'un tableau appartenant au Musée d'art et d'histoire," *Bulletin du Musée d'art et d'histoire* vol. 37 (1966): 37–46.
Schnapper, Antoine. *Jean Jouvenet (1644–1717), et la peinture d'histoire à Paris*. Paris: Laget, 1974.
-----. *Jean Jouvenet (1644–1717)*. Rouen: Musée des beaux-arts, 1966.

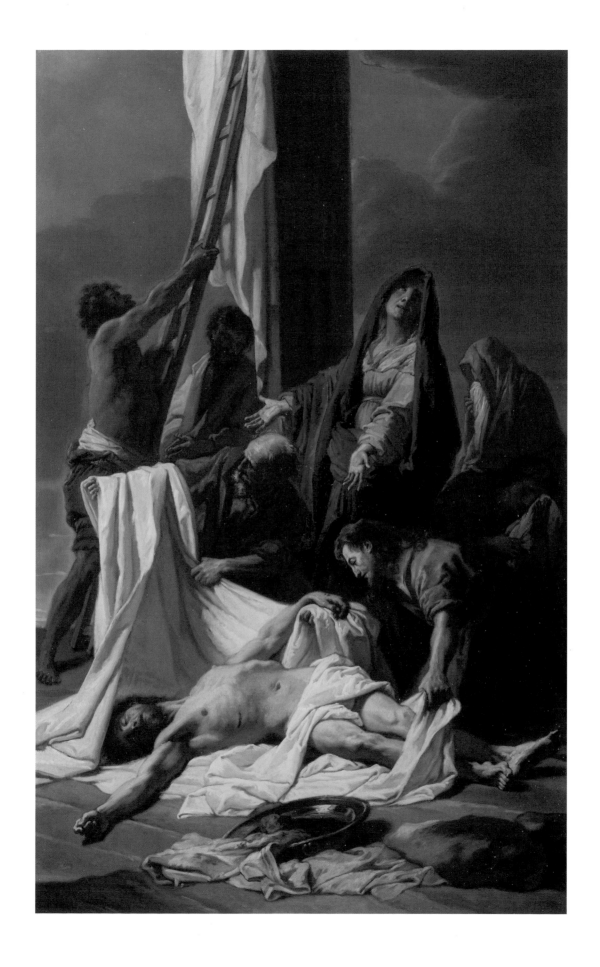

cat. 28

# Joseph Wright of Derby (British, 1734–1797)

*Antigonus in the Storm*

1790–92, oil on canvas, 153.9 x 221.3 cm
s.d.l.r. I.W. Pinx^t./1792
Gift of Joey and Toby Tanenbaum, 1990 (Inv. 90/167)

This dramatic coastal scene is based on Shakespeare's tragicomedy *The Winter's Tale* (1623; Act III, scene iii). Antigonus, a courtier, has been ordered to abandon the newborn child of Queen Hermione of Sicily because her husband, King Leontes, fears that the child is not his own. Although Antigonus tries to convince Leontes his concerns are unfounded, the king believes he is a conspirator and commands Antigonus to take the child far away and desert her. Antigonus takes pity on the infant Perdita (Latin: lost) but is attacked and killed by a bear. A shepherd then rescues Perdita. Perdita's royal heritage is later revealed and confirmed, she is reunited with her father, and marries the son of the king of Bohemia. *Antigonus in the Storm* depicts the moment when Perdita is abandoned and Antigonus is about to meet his end. Wright of Derby employs all the strengths of a Romantic landscape setting to evoke nature as sympathetic with the plight of humans. Antigonus' ship nearly capsizes next to the Bohemian coast, which is ravaged by torrential waves, and looming storm clouds begin to fill the sky. This sublime seascape with its imposing rocky coastline, roiling water, and forbidding sky fills the viewer with awe before the powerful forces of nature.

Wright of Derby produced this work later in his career when he was fascinated with themes from literature. He sought both to depict nature accurately and to employ poetic and theatrial strategies in his compositions. By the time he painted this work, Wright had already created a successful career as a portraitist and painter of contemporary scientific scenes. He undertook an extended trip to the Continent and lived in Rome for two years (1774–75), but spent most of his career in Derby, in the East Midlands. Wright was, in fact, the first major English artist who was based outside of London throughout his career. He was elected an Associate Member of the Royal Academy in 1783 and, having felt slighted by this lesser status, he declined the full membership he was offered the following year. He then ended his official relationship with the Academy, although he continued to contribute works to exhibitions through 1794. Wright completed an earlier version of *Antigonus in the Storm* in 1789–90 that was bought by publisher John Boydel and engraved for his Shakespeare Gallery, a place which was designed to promote engraving and history painting in England. Wright exhibited this, the second version, at the Royal Academy in 1790, where it was

placed in a bad location and received negative reviews. He reworked the canvas, exhibited it at the Society of Artists in 1791, and then sold it to businessman and early American settler Henry Phillips, brother of Wright's friend and patron John Leigh Phillips. The painting was later included in the collection of the Curzon family and was hung prominently in the portrait corridor at Kedleston Hall, Derbyshire, until that property transferred to the National Trust.

**Provenance**

Henry Philips (acquired from the artist)
Kedelston Hall, Derbyshire, Collection of Curzon family
   (by 1870), later Viscount Scarsdale
London, Christie's, 27 June 1980, n. 91
Toronto, Joey and Toby Tanenbaum, 1980–1990

**Exhibition History**

London, Royal Academy, 1790, n. 221
London, Society of Artists, 1791, n. 219
Derby, *Midland Counties Fine Arts and Industrial Exhibition*, 1870,
   n. 271
Derby, Corporation Art Galleries, *Paintings by Joseph Wright,
   A.R.A., commonly called "Wright of Derby," together with some
   original drawings, and a complete collection of Prints after his
   works on view*, 1883, n. 1
London, Tate Gallery, *Landscape in Britain c. 1750–1850*, 20
   November 1973–3 February 1974, n. 126
Derby, Derby Art Gallery, *Joseph Wright of Derby (1734–1797)*,
   21 April–21 July 1979, n. 36

**Bibliography**

Bemrose, William. *The Life and Works of Joseph Wright, commonly
   called 'Wright of Derby'.* London: Bemrose & Sons, 1885.
Egerton, Judy. *Wright of Derby.* London: Tate Gallery, 1990.
Friedman, Winifred H. *Boydell's Shakespeare Gallery.* New York:
   Garland Publishing, 1976.
Nicolson, Benedict. *Joseph Wright of Derby: Painter of Light.* 2 vols.
   New York: Pantheon Books, 1968.
Smith, Solomon Charles Kaines and Herbert Cheney Bemrose.
   *Wright of Derby.* New York: F. A. Stokes, 1922.

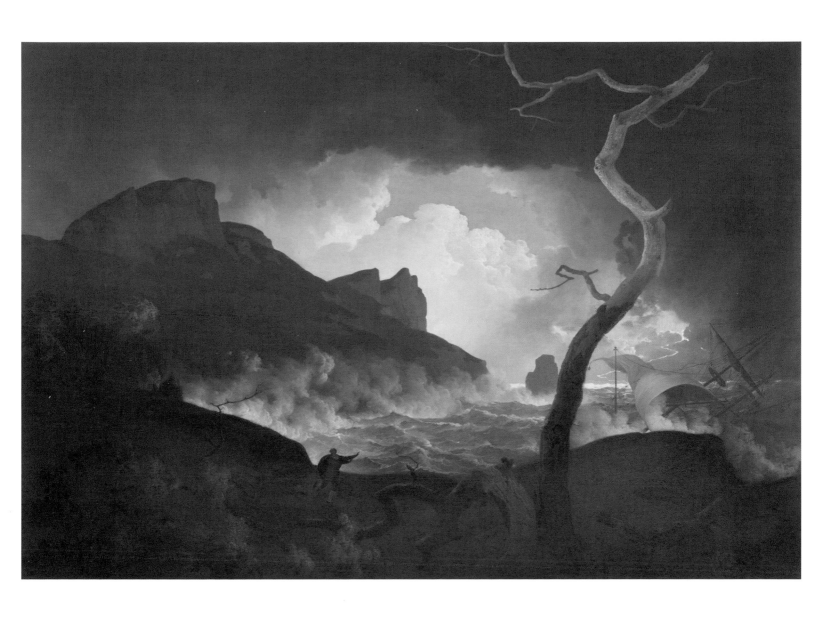

# Francisco Goya y Lucientes (Spanish, 1746–1828)
## *Los Caprichos*

1799, set of 80 prints, 1st edition, etching and aquatint with hand colouring, 21.4 x 15 cm
Gift of Joey and Toby Tanenbaum, 1999 (Inv. 99/618.1–99/618.80)

Capricho means fantasy, whim, or expression of imagination. Goya articulated his initial concepts for *Los Caprichos* in a large sketchbook in 1796–97 (Madrid album, now dispersed), in which he turned to caricatures and satirical drawings as a means of commenting on contemporary society, and in some instances included brief written inscriptions. Goya then developed his ideas in an important series of eighty prints, of which this is an exceptional early set from the first edition (before the scratch that appeared on plate 45). While the other eleven editions were published posthumously, this set was among those printed for Goya and first offered for sale by him beginning in February 1799. Instead of selling the prints at a bookshop, as was then customary, Goya had to make arrangements for them to be sold in a perfume and liqueur store right below where he lived at Calle del Desengaño 1 in Madrid. This was likely due to the ambiguous and potentially controversial nature of these prints. The unusual circumstances give us some sense of how difficult it was for Goya to disseminate his views about his fellow Spaniards. He attacks the greed and shallow pursuits of the upper-classes, as well as what he regarded as the uncritical piety, ignorance, and irrational superstitious beliefs of so many of his contemporaries. Goya challenges authority as well as the power assigned to religious orders and hereditary titles. He condemns idleness and licentiousness and argues that the proliferation of crime is the result of endemic poverty and lack of education. This set of prints must be understood within the context of the Age of Enlightenment as Goya advocated social reform and an end to political and religious abuses. Despite the efforts of King Charles III (r.1759–1788) to modernize Spain, Goya argues that his country is dominated by regressive institutional structures and social practices. Indeed the Spanish Inquisition established in the fifteenth century, although scaled back, was still in force in the late eighteenth century.

Goya includes a profile portrait of himself as the first plate in the series (cat. 29.1). His solemn expression and penetrating gaze position him as a witness to all that he condemns. An extant manuscript with Goya's explanations survives in the collection of the Prado Museum. It was initially planned that plate 43, *The Sleep of Reason produces monsters* (cat. 29.8), would introduce the series, but Goya repositioned this image to later in the set and warns that if one is not constantly vigilant, one's rational and prudent self will be vulnerable to attack. Later in the series Goya laments the possibility of Spaniards being freed from the shackles of tradition: *Is there no one to untie us?* (plate 75, cat. 29.11). In the final print he declares unequivocally *It is now time* (plate 80, cat. 29.12). While the potential meaning of some of these images remains open to our interpretation, others were difficult even for Goya's contemporaries to understand. Ambiguity was necessary to protect the artist and and that furtiveness has always been part of the appeal of these prints. Collectors sometimes wrote their interpretations of the inscriptions on the verso of the prints and others added hand-colouring, such as occurred with this set. The date at which the hand-colouring was applied to this set remains unknown, however it was likely an early owner. There are examples of comparable additions in the early nineteenth century.

As a painter-printmaker, Goya elected to work with etching, an immediate and spontaneous means of capturing his ideas. In this intaglio process, Goya used hatched and cross-hatched lines to produce a sense of texture and dramatic contrasts of light and dark. Plates 13 and 23 (cats. 29.4 and 29.5) exemplify how he also created atmospheric effects by using aquatint, a pourous resin that forms tonal areas of granular texture. Goya combined these techniques to produce a set of prints that is considered among the most powerful in the history of art. In 1799, the same year he produced *Los Caprichos*, Goya was appointed First Court Painter by King Charles IV (he had been appointed Pintor del Rey in 1786 under King Charles III), until the king was forced to abdicate in 1808 when Napoléon Bonaparte's army invaded Spain. Both during and after the Peninsular War Goya continued to produce sets of prints including the *Disasters of War* (1810–1820) and *Los Proverbios* (1816–1824) that likely because of their contentious subject matter he did not circulate. They remained unpublished until 1863 and 1864 respectively.

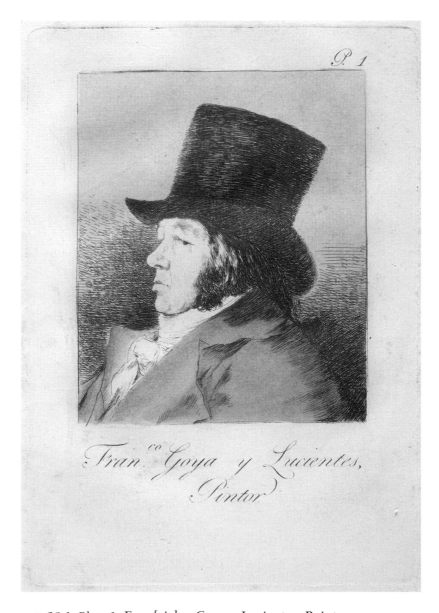

cat. 29.1  Plate 1  *Fran[cis]co Goya y Lucientes, Painter*

**Provenance**
Francisco Javier Goya (?)
Sir William Maxwell Stirling
London, Baskett & Day, 1977
Pasadena, Norton Simon Museum, 1977–1980
London, Norman Leitman, 1980
Toronto, Joey and Toby Tanenbaum, 1980–1999

**Exhibition History**
Toronto, Art Gallery of Ontario, 1 September–25 November
    2001, *Goya's Los Caprichos*

**Bibliography**
Andioc, René. "Al margen de los caprichos: las 'explicaciones'
    manuscritas," *Nueva Revista de Filología Hispánica* vol. 33
    (1984): 257–284.

Blas, Javier et al. *El libro de los caprichos, Francisco de Goya :
    dos siglos de interpretaciones (1799–1999)*. Madrid: Museo
    Nacional del Prado, 1999.

Lafuente Ferrari, Enrique. *Los Caprichos de Goya*. Barcelona:
    Gustavo Gili, 1978.

López-Rey, José. *Goya's Caprichos: Beauty, Reason and Caricature*
    2 vols. Princeton: Princeton University Press, 1953.

Pérez Sánchez, Alfonso E. and Eleanor A. Sayre. *Goya and the
    Spirit of Enlightenment*. Boston: Museum of Fine Arts, 1989.

Sayre, Eleanor. *The Changing Image: Prints by Francisco Goya*.
    Boston: Museum of Fine Arts, 1974.

Sánchez Cantón, Francisco Javier. *Los Caprichos de Goya y sus
    dibujos preparatorios*. Barcelona: Instituto Amatller de Arte
    Hispánico, 1949.

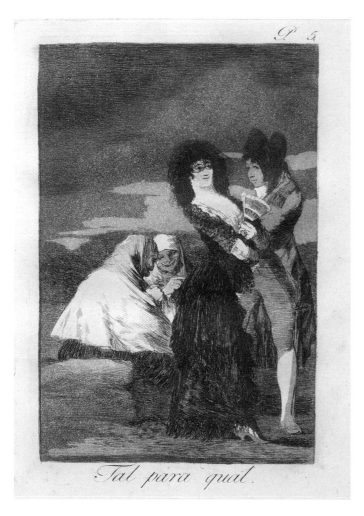

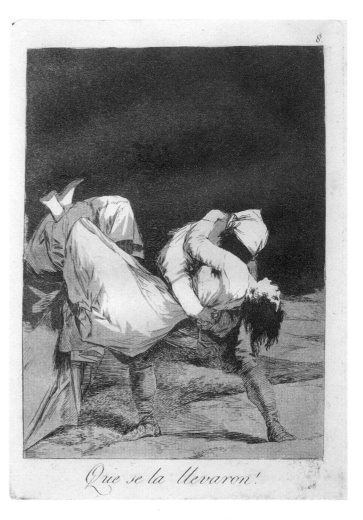

cat. 29.2  Plate 5  ***Two of a kind***

cat. 29.3  Plate 8  ***They carried her off!***

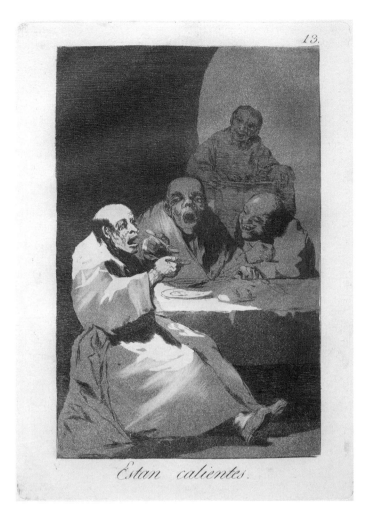

cat. 29.4  Plate 13  **They are hot**

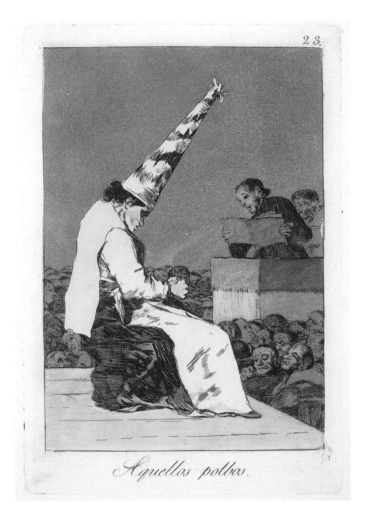

cat. 29.5  Plate 23  **Those specks of dust**

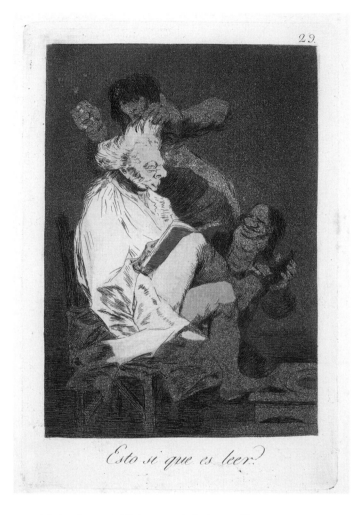

cat. 29.6  Plate 29  **This certainly is reading**

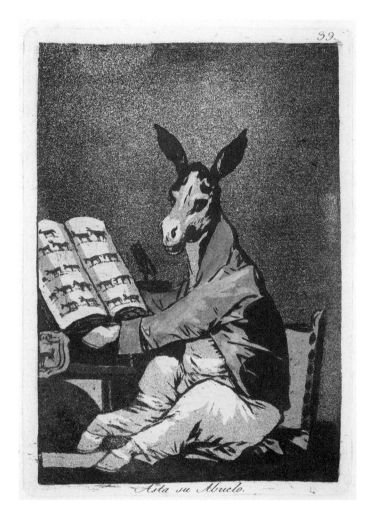

cat. 29.7  Plate 39  **As far back as his grandfather**

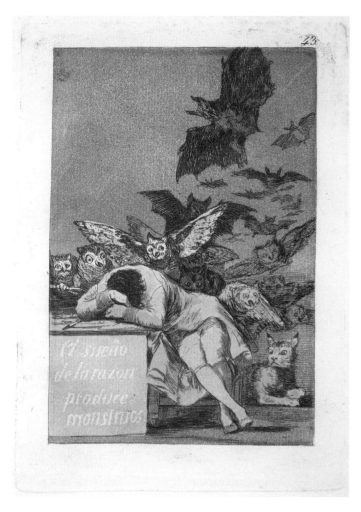

cat. 29.8  Plate 43  *The dream of reason produced monsters*       cat. 29.10  Plate 67  *Wait until you've been anointed*

cat. 29.11  Plate 75  *Is there no one to untie us?*

cat. 29.12  Plate 80  *It is now time*

*Soplones*

cat. 29.9  Plate 48  *Informers/Blowers of wind*

cat. 30

# Francisco Goya y Lucientes (Spanish, 1746–1828)

## *Los Proverbios*

1816–1824, set of 18 prints, 1st edition, etching, aquatint, lavis, burnisher, drypoint and burin, 24.2 x 35.1 cm
Gift of The Robert Tanenbaum Family Trust, 1999 (Inv. 99/528.1–99/528.18)

This series is also known as *Los Disparates*, the follies or absurdities, and was entitled *Los Proverbios* when it was published in 1864 because the subjects were then associated with Spanish proverbs. Goya produced proofs of this series during his lifetime and "disparates" was the first word of the short inscriptions that he included on some proofs. The eerie scenes include a depiction of women blithely oblivious to their position trapped out on the limb of a tree (Plate 3 *Ridiculous folly*, cat. 30.1), a large unintelligent figure who looms over others (Plate 4 *Simpleton*, cat. 30.2), men who masquerade as birds (Plate 13 *A way of flying*, cat. 30.3), and figures who assume guises as carnival characters (Plate 14 *Carnival folly*, cat. 30.4). *Los Proverbios* present ominous scenes as well as violent and ignorant human behavior and are considered Goya's most enigmatic prints. The series may manifest the disorder that pervaded Spanish society in the context of the French invasion, the rule of Napoléon Bonaparte's brother Joseph as King of Spain from 1808 to 1813, and the resulting Peninsular War. Goya certainly reveals his distaste in these prints for the civil strife and sycophantic conduct of many of his contemporaries.

To the etching and aquatint techniques (discussed in the entry on *Los Caprichos*), Goya also applied acid directly with a brush, in a lavis process that emulates the wash of an ink drawing. There are areas where the plates are scratched directly with a burin, the tool used for engraving. The finer and blurry lines were created with a drypoint needle. Other sections are burnished, meaning the paper was rubbed or polished, and appear much brighter. Goya produced a total of twenty-two scenes in this series, although extant unetched drawings suggest he must have decided it would not be possible for him to publish these works in his life-time. Goya was elected to the Real Academia de Bellas Artes in Madrid in 1780 and became Deputy Director of Painting in 1785. It was this institution that acquired eighteen of the plates in 1862 and oversaw the publication of *Los Proverbios* two years later, although the first posthumous publication occurred in 1848. As someone who undertook probing and often critical investigations of contemporary life, Goya is typically regarded as among the first modern artists.

**Provenance**
London, Norman Leitman
Toronto, Joey and Toby Tanenbaum 1981–1997
Toronto, Robert Tanenbaum, 1997–1999

**Exhibition History**
Toronto, Art Gallery of Ontario, 5 July–15 October 2000,
    *Nightmares of a Genius: Goya's Los Proverbios*
Halifax, Dalhousie Art Gallery, 23 May–6 July 2003, *Goya,
    Los Proverbios: Marvels & Monsters*

**Bibliography**
Camón Aznar, José. *'Los Disparates' de Goya y sus dibujos
    preparatorios.* Barcelona: Instituto Amatller de Arte Hispánico,
    1951.
Hofer, Philip. *The Disparates; or, The Proverbios.* New York:
    Dover, 1969.
Hollander, Hans. *Los disparates (Los Proverbios de Goya).*
    Tübingen: E. Wasmuth, 1968.
See also bibliography for entry on Goya's *Los Caprichos.*

cat. 30.1 Plate 3 *Ridiculous folly*

cat. 30.2  Plate 4  *Simpleton*

cat. 30.3  Plate 13  *A way of flying*

**Francisco Goya y Lucientes** *Los Proverbios*

cat. 30.4  Plate 14  *Carnival folly*

cat. 31

# Emile Jean Horace Vernet (French, 1789–1863)

## Pirates Fighting at Sunrise (Combat de corsaires, au lever de soleil)

1818, oil on canvas, 72 x 103.2 cm
s.d.l.r Horace Vernet 1818
Gift of Joey and Toby Tanenbaum, 1994 (Inv. 94/320)

In the center of a dramatic seascape, men in two boats engage in close combat as they battle with axe, spear, oar, and guns. When this work was exhibited at the Salon of 1819, the catalogue described the turbaned men as Algerian. One has already been killed, but we witness a tense moment when it is unclear whether the French men, who have intercepted the pirates, will indeed triumph. The partially exposed body of the French woman abducted by the Algerians is central to the conflict, as are the goods wrapped in yellow and white cloth at her feet. In the early nineteenth century, brigands roamed the Mediterranean along the Barbary Coast, and specifically from Algerian ports, until the French conquest of Algeria in 1830. Well after he completed this work, Vernet made several visits to Algeria between 1833 and 1853. His theatrical representation of violence — both the savage behavior between men and the powerful forces of nature — situate this painting within the Romantic tradition. Vernet's depiction of the Algerian men as vile thieves positions this work firmly within a nineteenth-century tradition of Orientalism, a cultural discourse in which people from North African and Middle Eastern cultures are assigned the position of "other" before Western Europeans, here specifically the French Salon audience. The same year that Vernet showed this painting at the Salon, Géricault exhibited the large scale Shipwreck (Raft of the Medusa) with its complex presentation of people from several races abandoned at sea. Vernet completed his work in 1818 and the similarities in pose with Géricault's figures suggest he may have been inspired by the work of his close friend Vernet, or perhaps Vernet was inspired by Géricault's preparatory work — the exact nature of the relationship remains unclear. Vernet's painting proved very popular and a lithograph by Antoine Maurin made the work available for mass consumption.

Son of Carle and grandson of Joseph Vernet, Horace studied with his father and François-André Vincent. He won a first class medal for his first Salon submission in 1812. Vernet was much favoured by the circle of the duc d'Orléans, who himself bought Pirates Fighting at Sunrise in November 1818 for 2,000 francs. Vernet included this work in an exhibition he mounted in his studio in 1822, where it was one of six works loaned from the collection of the duc d'Orléans. In the following years, Vernet was made an officer of the Legion of Honour in 1825, elected a member of the Institut in 1826, named director of the French Academy in Rome, 1828–34, and appointed professor at the Ecole des Beaux-arts in 1835.

Vernet enjoyed many commissions once the duc d'Orléans was named King Louis-Philippe in 1830 (to 1848) and continued to receive accolades during the Second Empire until his death in 1863.

## Provenance

Paris, Louis-Philippe, duc d'Orléans (later King Louis-Philippe), purchased 10 November 1818
Paris, Hôtel des Ventes, Domain d'Orléans, 28 April 1851, n. 183
France, Private Collection
Paris, Hôtel des Ventes, 1981
France, Private Collection
Paris, Peter Silverman
Toronto, Joey and Toby Tanenbaum, 1987–1994

## Exhibition History

Paris, Salon de 1819, n. 1162 (as Marine)
Paris, Salon d'Horace Vernet, 12 May–11 June 1822, n. 6 (as Marine)
Toronto, Art Gallery of Ontario, April-December 1993 (on long-term loan)
Nashville, Tennessee, Frist Center for the Visual Arts, European Masterworks: Paintings from the collection of the Art Gallery of Ontario, 8 April–8 July 2001, n. 45.
London, Tate Britain, 5 February–11 May 2003; Minneapolis, Minneapolis Institute of Arts, 8 June–7 September 2003; New York, Metropolitan Museum of Art, 7 October 2003–4 January 2004, Constable to Delacroix: British Art and the French Romantics, cat. 29

## Bibliography

Bona, Félix de. Une famille de peintres: Horace Vernet et ses ancêtres. Lille: Desclée de Brouwer et Cie., n.d.
Dayot, Armand. Les Vernet: Joseph-Carle-Horace. Paris: Magnier, 1898.
Duvivier, A. St.-Vincent. "Biographie: Horace Vernet (suite); catalogue des principales oeuvres d'Horace Vernet," Revue de l'art ancien et moderne (15 February 1863): 116.
Grigsby, Darcy Grimaldo. Extremities: Painting Empire in post-revolutionary France. New Haven: Yale University Press, 2002.
Jouy, Etienne de and Antoine Jay. Salon d'Horace Vernet. Analyse historique et pittoresque des quarante-cinq tableaux exposés chez lui en 1822. Paris: Ponthieu, 1822.
Noon, Patrick. et al. Constable to Delacroix: British Art and the French Romantics. London: Tate Publishing, 2003.
Vatout, Jean. Notices historiques sur les tableaux de la galerie de S.A.R. Mgr. le duc d'Orléans. Paris, 1826.
-----. Galerie lithographiée des tableaux de S.A.R. Monseigneur le duc d'Orléans. Paris, 1824.

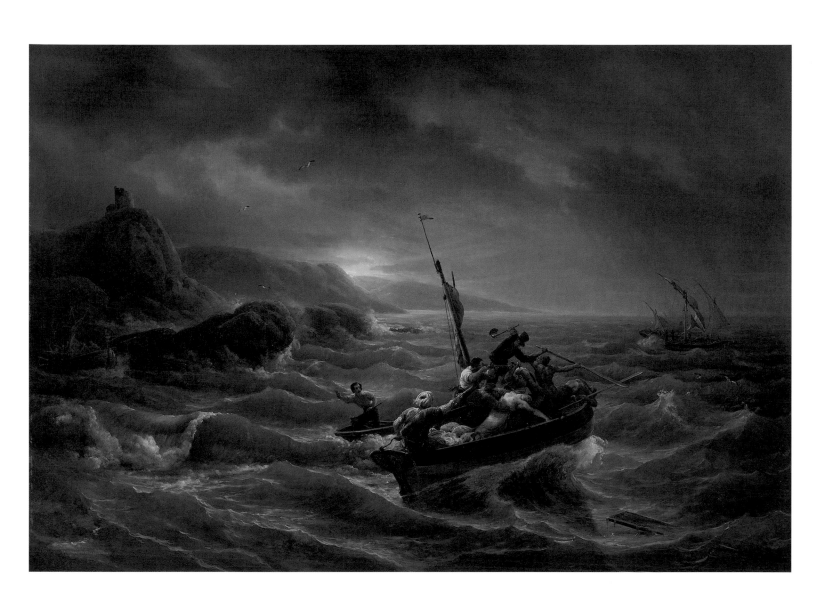

cat. 32

# Thomas Lawrence (British, 1769–1830)

## *Portrait of Hart Hart-Davis*

after 1820, oil on canvas, 76.7 x 63.7 cm
Gift from the collection of Dr. Anne Tanenbaum to the Government of Ontario, on long-term loan to the Art Gallery of Ontario, 1995 (AGOID.19499)

Hart was the son of Sarah and Richard Hart-Davis, a merchant trader with the West Indies and a Member of Parliament for Colchester and then Bristol. Richard was a prominent art patron and friend of Lawrence, from whom he commissioned his own portrait in 1815. Hart was also a Member of Parliament and enjoyed such a close friendship with Lawrence that he was a pallbearer at the artist's funeral in 1830. Lawrence painted two portraits of Hart, the first was his Eton Leaving Portrait in 1809 which, following custom, Hart presented to the college. About a decade later Lawrence painted the portrait in the AGO collection, along with one of Hart's wife Charlotte (Private Collection, U.S.A.). These pendant portraits, conceived as a pair and related in format, remained together first through family descendants and then private American collectors until the mid–1920s. In 1833, a few years after the artist's death, the pendants of Hart and Charlotte were exhibited together along with forty-one other paintings by Lawrence at the British Institution for Promoting the Fine Arts in the United Kingdom, a private society in London in existence from 1805 to 1867 that was also known as the Pall Mall Picture Galleries.

Lawrence is considered the greatest portrait painter of his generation in Europe. The *Portrait of Hart Hart-Davis* offers an excellent sense of his abilities to evoke mood and capture details that animate the sitter. In this half-length portrait, Hart-Davis stands before a stormy sky; he is caught in deep thought and looks out of the canvas to the viewer's left. The highlighted face, penetrating gaze, and strong definition of facial features all contribute to how Lawrence conveys a sense of the sitter's vigor. The finely detailed face contrasts with the more lively application of cream and white, that, with a splash of pink, forms the elaborate cravat and signals the sitter's sartorial elegance. These passages summarize much of the contrasting physicality and materiality that was central to Lawrence's success as a portrait painter. Lawrence was a child prodigy and entered the Royal Academy Schools in 1787 when it was under the direction of Sir Joshua Reynolds. Lawrence was elected an Associate Member of the Royal Academy in 1791 and a Member (R.A.) in 1794. He became Painter-in-Ordinary (principal painter) to George III following the death of Reynolds in 1792. In 1814 King George IV commissioned from Lawrence a series of portraits of the European

sovereigns that allied to defeat Napoleon at the Battle of Waterloo. He was knighted in 1815. Lawrence traveled extensively on the continent where he broadened what was already a distinguished reputation. Following his return to England in 1820 he was made President of the Royal Academy. Lawrence was an avid art collector, particularly of Old Master drawings, an expense which contributed to the financial difficulties that plagued him despite his successful career.

### Provenance

Bristol and London, R. Hart Davis (sitter's father)
The Reverend R.H. Hart Davis (by descent, to 1922)
London, Christie's, 14 July 1922, n. 26
New York, John Levy, 1925
Greenwich, CT, Mrs. William B. Weaver
New York, Sotheby's, 12 January 1989, n. 149
Toronto, Dr. Anne Tanenbaum, 1989–1991

### Exhibition History

London, British Institution, *Works of Sir Joshua Reynolds, Benjamin West, Esq. and Sir Thomas Lawrence, the three last presidents of the Royal Academy*, 1833, n. 29

### Bibliography

Armstrong, Sir Walter. *Lawrence*. London, Methuen, 1913.
Garlick, Kenneth. *Sir Thomas Lawrence: A Complete Catalogue of the Oil Paintings*. Oxford: Phaidon, 1989.
-----. *A Catalogue of the Paintings, Drawings and Pastels of Sir Thomas Lawrence*. London: The Walpole Society, 1964.
-----. *Sir Thomas Lawrence*. London: Routledge & Kegan Paul, 1954.
Gower, Ronald Charles and Algernon Graves. *Sir Thomas Lawrence*. London: Goupil, 1900.
Holmes, Richard. *Thomas Lawrence Portraits*. London: National Portrait Gallery, 2010.
Levey, Michael. *Sir Thomas Lawrence*. New Haven: Yale University Press, 2005.
Roberts, W. *Hart Davis, Jun., M.P., by Sir Thomas Lawrence, P.R.A.* London: Chiswick Press, 1922.

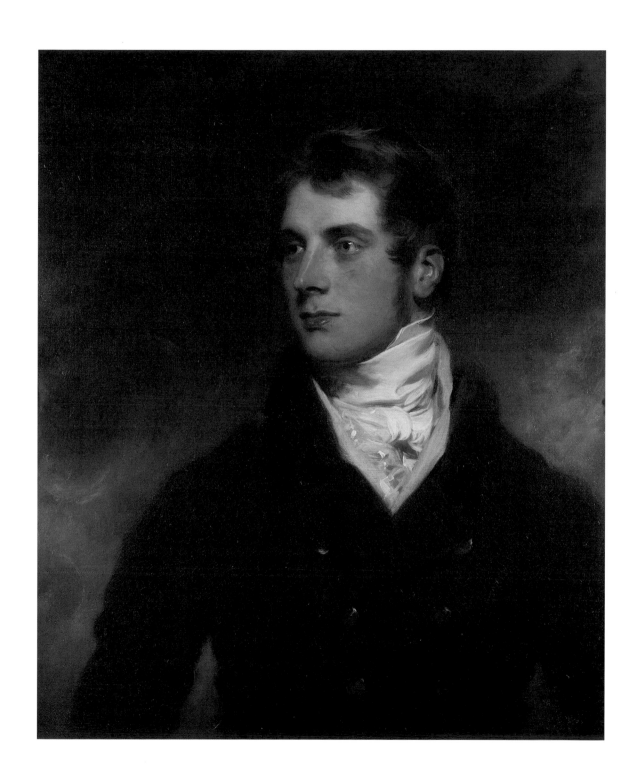

# Eugène Devéria (French, 1805–1865)
## *Portrait of the Comte Henri de Cambis d'Orsan*

1839, oil on canvas, 103.3 x 84.4 cm, s.d.l.r. Eug. Devéria/ 1839. Avignon
Gift from the collection of Dr. Anne Tanenbaum to the Government of Ontario, on long-term loan to the Art Gallery of Ontario, 1995 (AGOID.19500)

Devéria presents the count as a dapper figure carrying a top hat and cane and posing before a moody landscape setting. The buildings on the left situate him before his native town of Avignon, where Devéria himself moved in 1838 and was at work on an important decorative cycle at the Cathedral Notre-Dame-des-doms. This portrait was likely commissioned by the comte d'Orsan or his father Auguste de Cambis, the marquis d'Orsan, who was a significant political figure in the Vaucluse department in southeastern France. Auguste was elected to the central government in Paris where he was active in parliament through the 1830s and early 1840s. The family belonged to the *notables*, a group of individuals with high social standing and wealth who contributed to French society through their involvement in parliament. In fact, this portrait was painted in 1839, two years after the sitter's father had been assigned the title of marquis. A confident looking Henri-François-Marie-Augustin was twenty-nine when Devéria painted this portrait and the strong definition of his tailored form is representative of upper-class fashion. Several *pentimenti*, areas of underpainting that are now evident, also suggest how Devéria reworked the jacket to emphasize the count's physique and thus highlight his status as a stylish dandy. Indeed the work exemplifies Devéria's ability to model forms, and he painted a particularly captivating representation of the sitter's face as thoughtful and intelligent. The suggestion of a vast landscape with a colourful sunset adds to the romantic nature of the portrait and likely also refers to the family's considerable property near Avignon. Comte Henri de Cambis d'Orsan went on to serve as an elected deputy for Avignon in 1842 and again in 1846 and was a strong supporter of the July Monarchy until his early death in 1847.

Devéria studied with Girodet and Lethière, exhibited works at the Salons in Paris beginning in 1824, and enjoyed his first success with *Birth of Henry IV* in 1827, which is now in the collection of the Louvre museum. He received numerous official commissions and was among the artists King Louis-Philippe asked to decorate the Musée de l'histoire de France at Versailles, for which Devéria painted several works including *Oath of King Louis-Philippe before the Chamber of Deputies* in 1836. He was also active as a painter of religious subjects and was very well regarded as a portraitist. Devéria was based in Pau from 1841 and regularly contributed works to the Salons until his death. For most of his life Eugène enjoyed a close relationship with his older brother Achille (1800–1857), who was a painter, lithographer, and designer of stained glass.

**Provenance**
London, Heim Gallery, 1988–1989
Toronto, Dr. Anne Tanenbaum, 1989–1995

**Exhibition History**
London, Jane Roberts & Max Rutherston, *'Portraits and People': Paintings and Drawings 1800–1950*, 1–29 March 1988
London, Heim Gallery, *Towards a New Taste*, 24 May–25 July 1989, n. 14
Toronto, Art Gallery of Ontario, 1991–1995, on long-term loan
Nashville, Frist Center for the Visual Arts, *European Masterworks: Paintings from the collection of the Art Gallery of Ontario*, 8 April–8 July 2001, n. 47
Ocala, The Appleton Art Museum, *19th Century European Masterworks from the Collection of the Art Gallery of Ontario*, 8 September–6 December 2001

**Bibliography**
Gautier, Maximilien. *La Vie et l'Art romantiques. Achille et Eugène Déveria*. Paris: H. Floury, 1925.
Mironneau, Paul and Guillaume Ambroise. *Eugène Devéria, 1805–1865*. Paris: RMN, 2005.
Ojalvo, David. *Eugène Devéria (Paris 1805-Pau 1865)*. Pau: Musée des beaux-arts, 1965.
Weisberg, Gabriel P. "The New Portraiture: Painting," in *The Art of the July Monarchy: France 1830 to 1848*. Columbia: University of Missouri Press, 1989, 138–140.

# Auguste Rodin (French, 1840–1917)

## *Andrieux d'Andres* (also known as *Andrieux d'Andres, vêtu*)

Conceived 1887, cast 1988, bronze, 220.7 x 135.5 x 88.5 cm
Signed on socle left of foot: Rodin
Inscribed on socle left of foot: 7/8 and at rear Courbetin Foundry © Musée Rodin 1988
Gift of Joey and Toby Tanenbaum, 1992 (Inv. 92/309)

## *Eustache de Saint-Pierre*

Conceived 1887, cast 1987, bronze, 214.5 x 303.5 x 205 cm
Signed on socle left of foot: A. Rodin
Inscribed on socle left of foot 6/8 and at rear Courbetin Foundry © Musee Rodin 1987
Gift of Joey and Toby Tanenbaum, 1992 (Inv. 92/310)

These two bronze casts are individual figures from Rodin's masterpiece *The Burghers of Calais*, originally commissioned by the city of Calais for a site in front of the town hall. The subject of the burghers, or citizens of Calais, relates to events from 1347, during the Hundred Years' War, when the English King Edward III (1312–1377, r. 1327–1377) captured and held the coastal town in northern France. As the English blocked the town's port for more than a year, the French King Philip VI told the town to resist at all costs. As a result the citizens of Calais faced starvation. Six men offered themselves as hostages and were prepared to sacrifice their lives in order to save their fellow townspeople. Even though they are separated from the context of their original multi-figure grouping, these two figures capture all the emotional intensity of the full work and thus exemplify the success of Rodin's probing study of the human figure and innovative handling of surfaces. Rodin competed for this commission and won over the committee with his *maquette*, a plaster study that placed six figures dressed in Renaissance clothing high on a podium that resembled a triumphal arch. He based his idea on a fourteen-century account by chronicler Jean Froissart that was written several decades after the original events and offered Rodin a rare primary document from which to draw inspiration. Froissart detailed the harsh terms of King Edward III's conditions: the hostages were to present themselves barefoot and in sackcloth, with ropes tied around their necks, and bearing the keys to the city and fortress. The king was to be free to do with them as he chose. Ultimately the men were spared due to the intervention of his wife, the then pregnant Queen Philippa of Hainault (1314–1369), who thought their death would be a terrible omen for their unborn child.

After receiving the commission, Rodin decided his proposal was too conventional and changed his conception of the work entirely. He placed the figures at ground level rather than high up on a pedestal and exchanged period dress for sackcloth. Instead of confident men moving forward together to their destiny he represented six individuals who are unified by the composition but seem to have little awareness of one another. Because Rodin placed the figures at ground level, the viewer feels a part of their experience. Rodin's expressive handling of the worked surfaces – the musculature, veins, and facial expressions – conveys the realism of his final work, which was the product of numerous studies of each figure and face. The final conception was not well received by the representatives of Calais who expected a heroic public monument along the lines of the proposal. In the context of France's Third Republic in the years following the devastating losses of the Franco-Prussian war (1870–71), civic authorities sought monuments that adhered to a more traditional presentation of heroism and patriotism. There was a desire to celebrate the glorious events of France's history and while the story of the burgher's willingness to sacrifice themselves would have fulfilled that need, Rodin's chosen modes of representation did not. It was only after a decade of controversy that the work was finally cast in bronze and displayed in Calais.

The two figures *Andrieux d'Andres* (holding his head) and *Eustache de Saint-Pierre* (the eldest burgher and the first to offer himself) are among the casts conceived by Rodin in 1887 following the completion of the multi-figure grouping. Cast in bronze by the Courbetin foundry in the late 1980s they are inscribed with a copyright by the Musée Rodin. These are defined as posthumous but at the same time original casts because they are authenticated by the Paris museum that was heir to over 7,000 plasters and Rodin's personal archive. The legal documents of the bequest allow for the production of up to 12 original casts of each work either during or after Rodin's lifetime. *The Burghers of Calais* is among Rodin's most famous works, along with *The Kiss* (1886), *Monument to Balzac* (1891–98), and *The Gates of Hell* (1880–1900; cast 1925), the figures of which Rodin developed in the form of numerous independent sculptures such as *The Thinker* (1881).

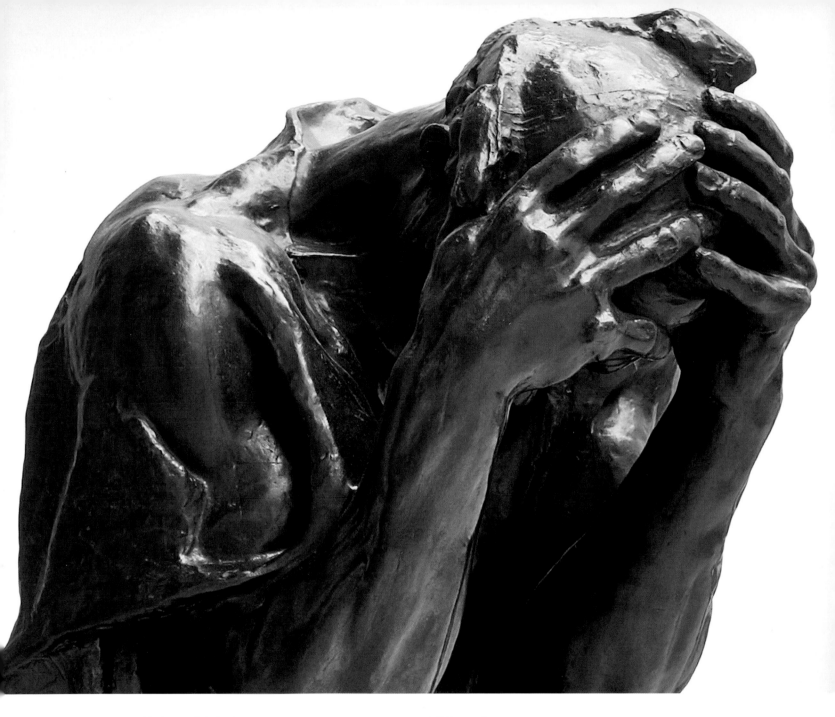

**Provenance** (*Andrieux d'Andres*)
London, Bruton Gallery, 1989
Toronto, Joey and Toby Tanenbaum, 1989–1992

**Exhibition History**
Québec City, Musée du Québec, *Rodin à Québec*,
 4 June–6 September 1998, cat. 56

**Provenance** (*Eustache de Saint-Pierre*)
London, Bruton Gallery, 1988
Toronto, Joey and Toby Tanenbaum, 1988–1992

**Exhibition History**
Toronto, Four Seasons Centre for the Performing Arts,
 16 September 2010–19 September 2011

**Bibliography**
Lerner, Abraham. *Auguste Rodin: the Burghers of Calais.*
 Washington D.C.: Museum Press, 1976.
Le Normand-Romain, Antoinette and Annette Haudiquet.
 *Rodin: The Burghers of Calais.* Paris: Musée Rodin, 2001.
McNamara, Mary Jo. "Rodin's Burghers of Calais," Ph.D.
 Dissertation, Stanford University, 1983.
Roos, Jane Mayo. *Rodin.* New York: Phaidon, 2010.
Schmoll gen Eisenwerth, J. Adolf. *Auguste Rodin: die Bürger von
 Calais, Werk und Wirkung.* Ostfildern-Ruit: G. Hatje, 1997.

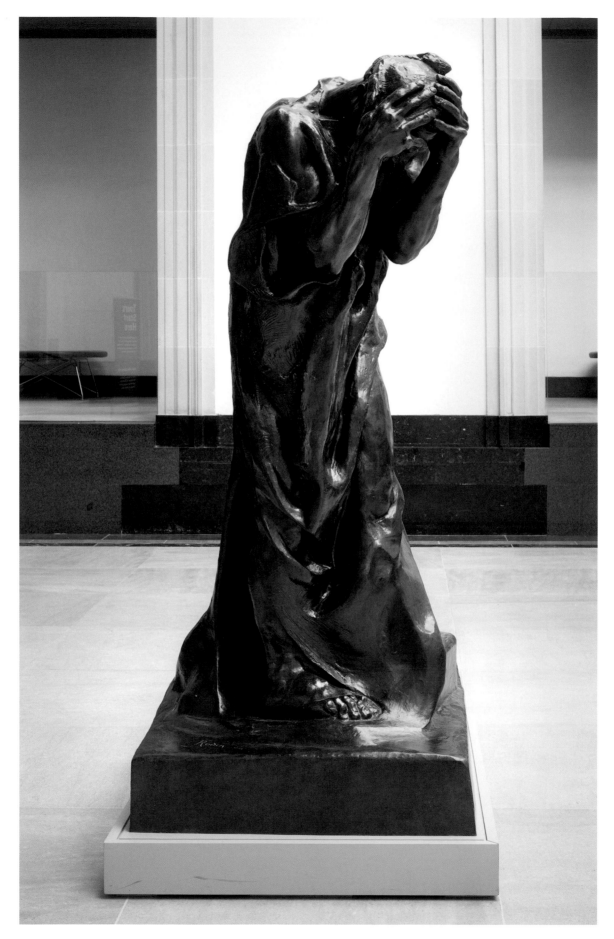

cat. 34
**Auguste Rodin** *Andrieux d'Andres* (also known as *Andrieux d'Andres, vêtu*)

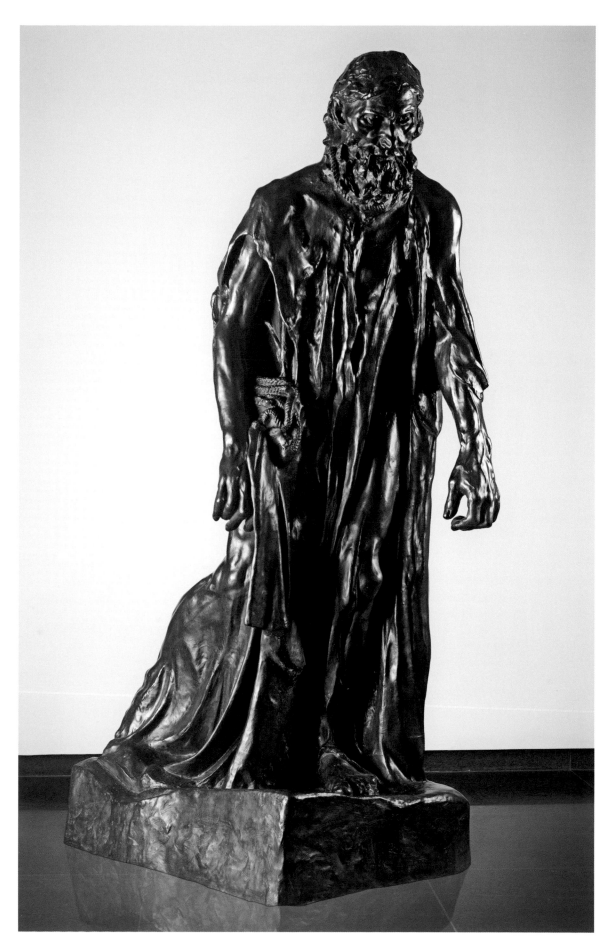

cat. 35
**Auguste Rodin** *Eustache de Saint-Pierre*

# George Frederick Watts (British, 1817–1904)
## *The Sower of the Systems*

1902, oil on canvas, 122.6 x 91.4 cm
s.l.r.c. G. Watts
Gift of Joey and Toby Tanenbaum, 1971; donated by the Ontario Heritage Foundation, 1988 (Inv. L70.7)

Details slowly emerge the longer you look at the massive form in the middle of this composition. Drapery billows and twists around the figure of God, who we see from the back in the midst of the awe-inspiring act of creation. With extended observation, a more detailed heel and foot emerges in the lower left hand corner that connects with this mighty being. This is the fourth day of creation, when God created the sun, the moon, and the stars (Genesis 1: 14–19). Streaks of light encircle God's form and convey his force. Watts presents God's hand as a powerful instrument and yet an amorphous shape with minimal detail. Indeed Watts' entire approach to this work can be seen as what was only later understood as abstraction. Watts alters his application of paint in the areas where we experience the energy of God's force. We are struck by the materiality and active surface texture, particularly where light emerges from God's hand and flows around his body.

Watts studied at the Royal Academy beginning in 1835 and with prize money from a competition he enjoyed an extended stay in Italy from 1843 to 1847, where he was inspired in particular by Renaissance fresco painting. Watts was a popular Victorian artist associated with the Symbolists, a late nineteenth-century movement that in the visual arts included much mythological and dream imagery. He was elected an Academician in 1867 and received the Order of Merit in 1902. Painted the same year, *The Sower of the Systems* is among Watts' late works and he had long been interested in astronomical and cosmic subjects. According to his wife, the Scottish artist Mary Fraser-Tytler, "This subject was suggested by the reflection upon the ceiling from a night light. In this the painter's imagination saw the veiled figure, projected as it were, through space — the track marked by planets, suns and stars cast from hand and foot." Watts himself wrote of this work, "My attempts at giving utterance and form to my ideas are like those of the child who, being asked by his little sister to draw God, made a great number of circular scribbles…but there was a greater idea in it than in Michelangelo's old man with a long beard." Although critical of Michelangelo's aged representation, Watts is certainly indebted to the images of God in the Sistine ceiling. This is one of two versions Watts painted of the subject. It is larger than the later composition now in the Watts Gallery in Compton and it was likely this earlier version that Watts exhibited at the New Gallery the year before his death.

## Provenance

Collection of Howard Pease
Collection of Lord Daryngton
London, Leger Galleries, 1954
New York, James Coats Gallery
London, Charles Jerdein
Toronto, Joey and Toby Tanenbaum, 1965–1971

## Exhibition History

London, New Gallery, 1903, n. 89
Newcastle upon Tyne, Laing Art Gallery, *Special Loan Collection of Works by the Late G.F. Watts, R.A., O.M.*, 1905, n. 36
Toronto, Art Gallery of Ontario, 1969–1971 (on long-term loan)
Toronto, Art Gallery of Ontario, *The Sacred and the Profane in Symbolist Art*, 1–26 November 1969, cat. 17
Rotterdam, Boyman van Beuningen Museum, 14 November 1975–11 January 1976; Brussels, Musées Royaux des Beaux-Arts, 23 January–7 March 1976; Baden-Baden, Staatliche Kunsthalle, 20 March–9 May 1976; Paris, Grand Palais, 21 May–19 July 1976, *Le Symbolisme en Europe*, cat. 255
Saskatoon, Saskatoon Gallery, *Victorian England in Canada*, 5–31 October 1976, n. 30
Minneapolis, Minneapolis Institute of Art, 19 November 1978–7 January 1979; Brooklyn, Brooklyn Museum, 10 February–8 April 1979, *The Victorian High Renaissance*, cat. 34b
Toronto, Art Gallery of Ontario, *Painters and Poets: An Educational Exhibition of British Art and Literature, 1860–1950*, 23 February–23 March 1980, cat. 70
Kofu, Yamanashi Prefectural Art Museum, 8 April–7 May 1989; Osaka, Daimaru Museum, 24 May–12 June 1989; Yamaguchi, Yamaguchi Prefectural Museum of Art, 30 June–30 July 1989; Kurume, Ishibashi Museum of Art, 5 August–8 September 1989; Tokyo, Isetan Museum of Art, 14 September–17 October 1989, *Victorian Dreamers: Masterpieces of Neo-Classical and Aesthetic Movements in Britain*, cat. 11

## Bibliography

Bills, Mark and Barbara Bryant. *G.F. Watts: Victorian Visionary*. New Haven: Yale University Press, 2008.
Gould, Veronica Franklin et al. *The Vision of G.F. Watts OM RA (1817–1904)*. Guilford: Watts Gallery, 1994.
Maas, Jeremy. *Victorian Painters*. London: Barrie & Rockcliffe, the Cresset Press, 1969.
Stewart, David. "Theosophy and Abstraction in the Victorian era: The Paintings of G.F. Watts," *Apollo* vol. 138 (November 1993): 298–302.
Watts, Mary S. Fraser-Tytler. *George Frederick Watts*. London: Macmillan, 1912.
Wilton, Andrew et al. *The Age of Rossetti, Burne-Jones and Watts: Symbolism in Britain, 1860–1910*. New York: Flammarion, 1997.

# Prince Paolo Troubetzkoy (Russian, 1866–1938)

## *Portrait of Comte Robert de Montesquiou-Fézensac*

c. 1910, painted plaster, 147.3 x 114.3 x 152.4 cm
Gift of Mr. and Mrs. Max Tanenbaum, 1971; donated by the Ontario Heritage Foundation, 1988 (Inv. L71.26)

Paolo Troubetzkoy was the second son of Russian prince Peter Troubetzkoy and American singer Ada Winans. His family's villa was often frequented by members of the *Scapigliati, Gli.*, an avant-garde artistic and literary group in Milan of the 1860s and 70s. The group took its name from Cletto Arrighi's (pseudonym for Carlo Righetti) novel *Scapigliatura* published in 1862. The term *scapigliato*, often applied to the spirit of youthful restlessness and independence promoted by this group, is also used in reference to Troubetzkoy's work. Troubetzkoy was primarily self-taught although he admired the work of Giuseppe Grandi who was part of the *scapigliatura*. Troubetzkoy was inspired by the modelling and impact of light cast on the surfaces of Grandi's sculpture. After Troubetzkoy moved to Russia in 1898, he became friends with Leo Tolstoy and his work became stylistically affiliated with the Russian realist group *Peredvizhniki*, known in English as the Itinerants or Wanderers. Troubetzkoy taught sculpture in Moscow at the Academy of Fine Arts, won the Grand Prix at the Exposition Universelle in Paris in 1900, and exhibited bronzes at the Salon d'automne in 1904.

Troubetzkoy lived in Paris from 1905 to 1914 and it was during this period that he produced *Portrait of Comte Robert de Montesquiou-Fézensac*. During those same years he also sculpted portraits of Anatole France, Auguste Rodin, Henry de Rothschild, Gabriele D'Annunzio and George Bernard Shaw. It was Shaw who wrote, "Prince Paul Troubetzkoy is one of the few geniuses of whom it is not only safe but necessary to speak in superlatives. He is the most astonishing sculptor of modern times." Marie Joseph Robert Anatole, comte de Montesquiou-Fézensac (1855–1921, often referred to as Robert de Montesquiou) was a Symbolist poet, essayist, novelist, art collector, and fashionable dandy whose portrait was painted by Whistler and Boldini. Troubetzkoy successfully captures Robert de Montesquiou's distinctive physiognomy, moustache, and his elegant hands. Indeed the pose is close to that found in Boldini's portrait now in the Musée d'Orsay (1897). But where Boldini represented his subject as a society figure in formal clothing and carrying a walking stick, then a trope of the public *flâneur*, Troubetzkoy focuses on Robert de Montesquiou as writer and intellect who pauses in contemplation from reading the book held in his right hand. The massivity of his clothes,

a dressing-gown or cloak worn in private, melds with the substantial armchair. Troubetzkoy's active surface conveys the lively personality and energetic intellectual life he clearly admired in his sitter.

### Provenance

Brussels, Galerie Vaughan, 1971
Toronto, Mr. and Mrs. Max Tanenbaum, 1971
Toronto, Ontario Heritage Foundation, 1971; on loan to Art Gallery of Ontario

### Bibliography

*An exhibition of sculpture by Prince Paul Trouetzkoy*. St. Louis: City Art Museum, 1912.

Brinton, Christian. *Exhibition of Sculpture by Prince Paul Troubetzkoy*. Detroit: Detroit Institute of Art, 1916.

-----. *Catalogue of Sculpture by Prince Paul Troubetzkoy*. Buffalo: American Numismatic Society, 1911.

Giolli, Raffaello. *Paolo Troubetzkoy*. Milan: Alfieri & Lacroix, 1913.

Grioni, John S. "Le Sculpteur Troubetzkoy," *Konsthistorisk Tidskrift* vol. 62 n. 1 (1993): 22–32.

-----. *Prince Paul Troubetzkoy's portraits in bronze*. London: National Magazine Company, 1984.

Pica, V. "Artisti contemporanei: Paolo Troubetzkoy," *Emporium* vol. 12 (1900): 2–19.

*Portraits in bronze and marble by Paul Troubetzkoy*. New York: Knoedler & Co., 1914.

Shaw, Bernard. *Sculpture by Prince Paul Troubetzkoy*. London: Colnaghi & Co., 1931.

Venturoli, Paolo and Gianna Piantoni. *Paolo Troubetzkoy, 1866–1938*. Turin: Il Quadrante, 1990.

Wootton, Oliver. *Prince Paul Troubetzkoy: the belle époque captured in bronze*. London: Sladmore Gallery, 2008.

## List of Artists

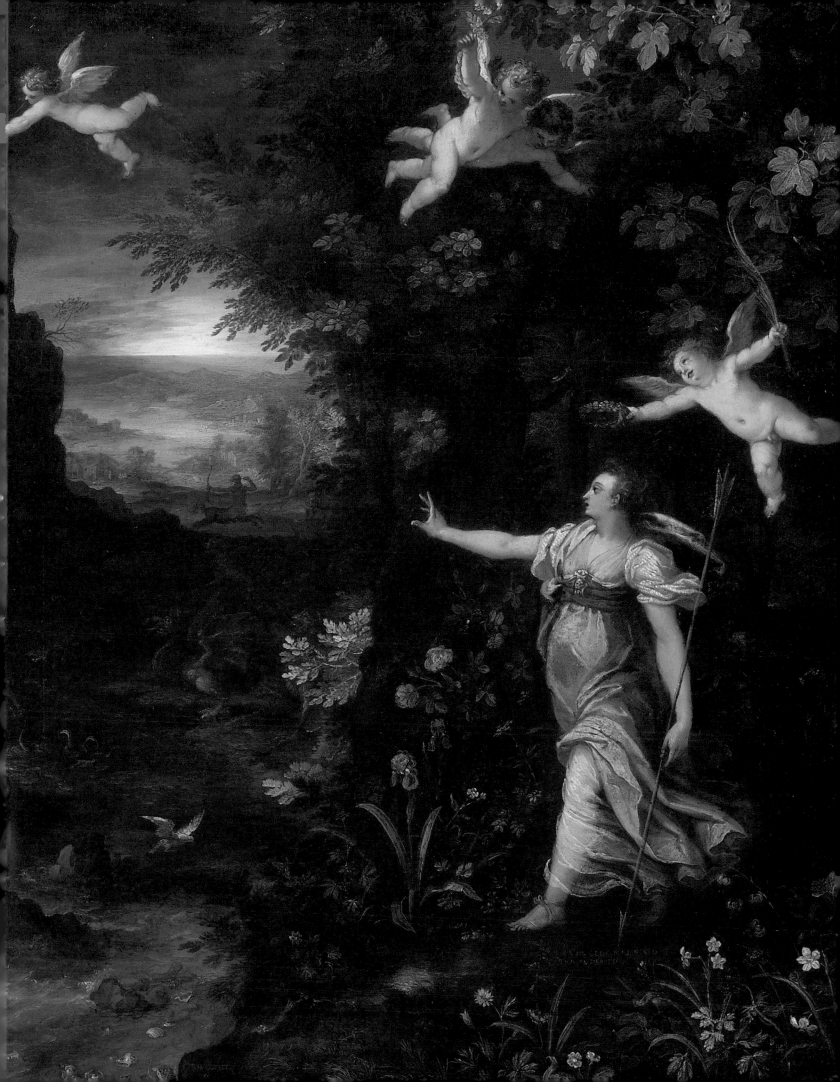

ISBN 978-1-927371-32-9

---

Printed and bound in Canada.